CREATIVE STAINED GLASS

17 step-by-step projects for stunning glass art and gifts

NOOR SPRINGAEL

GLAS & GLAS

T0322405

DAVID & CHARLES

www.davidandcharles.com

Contents

THE PROJECTS

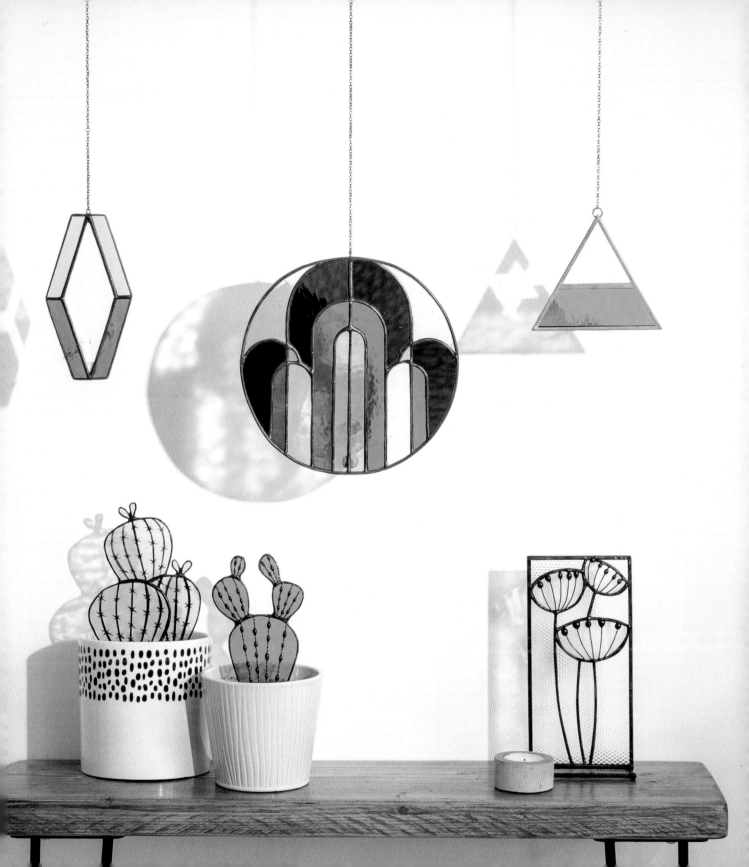

Introduction

Welcome to the world of glass, a world full of colour and light. Glass is not the easiest material to work with, but it is well worth the effort and once you enter a glass shop and you see all the available colours, you will probably be smitten anyway. I know I was and I still am. Every time I pick up a piece for the first time and the light falls through it, I fall in love all over again. There's no other medium that captures light the way glass does.

I will show you how to work with several types of glass, as well as metals such as copper, brass and lead. I chose to work with materials that are readily available to buy to make the projects in this book as accessible as possible. However, working with recycled materials and leftover glass is always my preference. It really is worth looking for second-hand glass and tools.

I'll show you the basics of painting on glass with traditional glass paints, fired in a kiln. But don't let a lack of a kiln put you off as I'll describe ways to add details to your work with wire and I've found a good alternative to traditional paint that doesn't require a kiln.

In this book, I will teach you step-by-step how to make all kinds of home decoration: suncatchers, small panels, planters and even mirrors. The possibilities with copper foil and glass are endless. I will be sharing all my tips and experience with you and hope that you will be inspired to make your own creations afterwards.

It's not always easy to come up with ideas so if you are finished with the projects in my book there's a lot of projects available online. But please make sure the template you pick is free: copying other people's work is not okay.

One last thing before you start: don't be afraid to start cutting glass – you will find it much easier than you ever expected.

Enjoy!

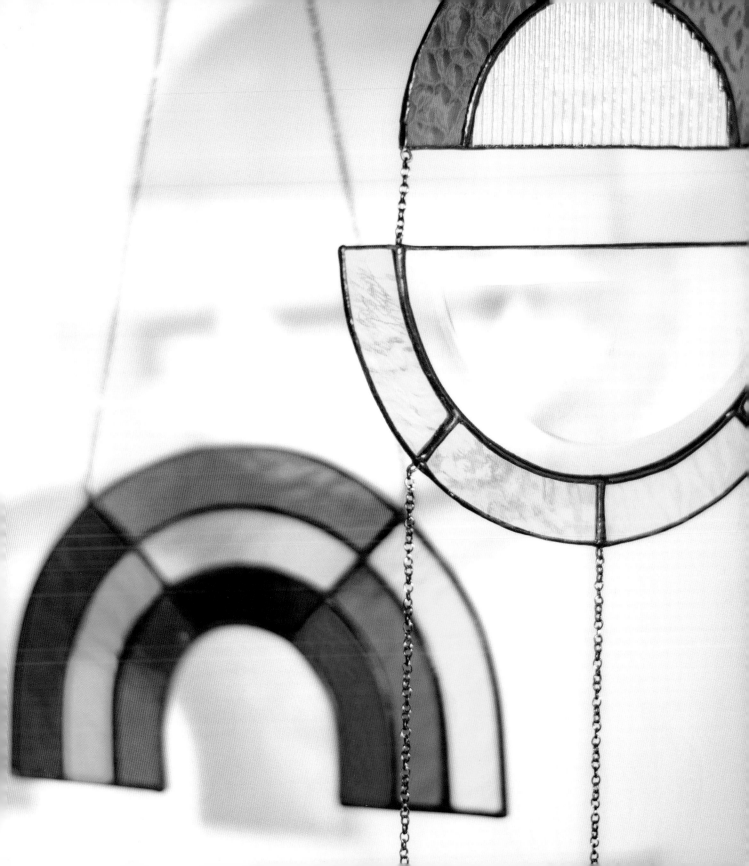

About Stained Glass

Stained glass is an old art form: the oldest painted glass windows that are still in place date from around 1,000 A.D. and are to be found in Germany. Even though stained glass originated as a mostly ecclesiastic art form, it evolved. At the end of the 19th century, inspired by the Art Nouveau movement, stained-glass windows became more common in houses. This continued into the 20th century with the Art Deco movement. These two art movements are still a big inspiration for me and a lot of other glass artists too.

In Europe, we mostly worked with led to create stained glass windows, but at the end of the 19th century American designer Louis Tiffany came up with a new technique that allowed him to make windows and his world-famous lamps. The technique is therefore often referred to as the 'Tiffany technique', but I prefer to use the broader term 'copper foil technique' to avoid confusion: lamps made with the copper foil technique are often called Tiffany lamps but they're not all made by Louis Tiffany!

The copper foil technique opened up a world of possibilities as it made creating smaller pieces and 3D glass art at home much easier and this led to a growing interest in the craft in the second part of the 20th century.

Over the last ten years, there's been a huge increase in people interested in crafts in general and stained glass in particular. This is partly due to a new generation of glass artists creating more contemporary pieces that speak to a wider audience. The interest in home decor continues to be popular and it's this side of glass art that I focus on in this book.

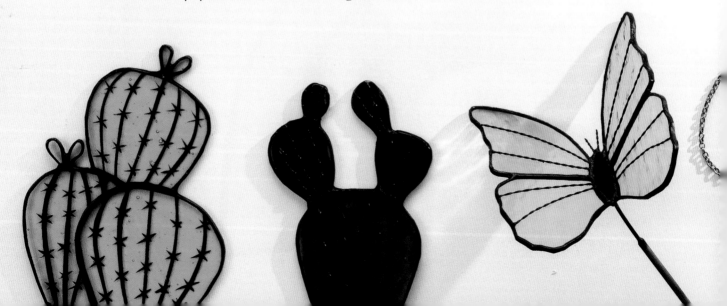

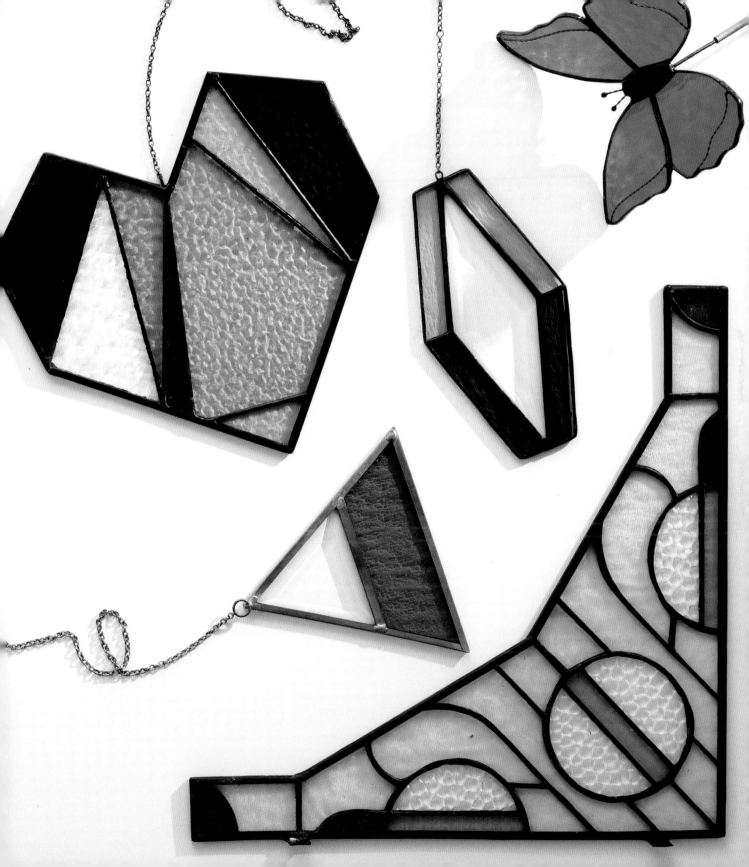

Materials

In this section, I'll give you an overview of the different kinds of glass available and the differences between them. I'll also provide you with a list of metals that can be used with copper foil, as well as the different chemicals I use.

Glass

There are several glass companies that produce coloured glass.

In this book, I use mostly machine-made sheet glass from Oceanside Glass & Tile company. But for some projects I also use Bullseye Glass and/or Wissmach Glass. I opted for glass that is easily available and relatively affordable, and stayed away from mouth-blown glass (or antique glass) since it's much more expensive.

Glass from each factory has its own characteristics but most of it used for stained glass is around 3mm to 4mm (⅛in to ⁵⁄₃₂in) thick. Sheet sizes differ for each manufacturer, but most stained-glass shops have small sheets available.

You can also distinguish glass by its texture or pattern. Each manufacturer has its own codes that refer to colour and the surface properties of the glass. For example, Cherry Red Oceanside Glass always has the code 151 but if it's followed by RR, the surface is Rough Rolled or if it says 151S, the surface is smooth.

Glass does not age, it only breaks, so if you are able to find it second-hand, don't hesitate to buy it if you like it.

When I refer to transparent glass, I'm not referring to just clear glass but to all glass that you can easily see through, whatever the colour. This is opposed to opaque glass that you can't see through.

For four of the projects, I use bevels. These are made from thick transparent glass with an angled surface (facet) around the whole piece. Bevels act like a prism in sunlight. You can buy them premade in different shapes and sizes.

Mirror is a special kind of glass. You can only cut it on one side, and you need to be extra careful when working with mirror to avoid scratches. I suggest you go for 2mm (³⁄₃₂in) or 3mm (⅛in) mirror. Although 4mm (⁵⁄₃₂in) is standard, it's much harder to cut.

Another thing to keep in mind is that there are products we use to make stained glass (such as flux and patina) that can damage the mirror layer. They will cause black stains (or mirror rot) on your mirror. To avoid this, you'll need to protect the edges after cutting. You can do this by applying a layer of mirror edge sealer or clear nail polish.

MEASURING GLASS FOR YOUR PROJECTS

You can determine how much glass you need for each project by measuring all the pieces of the same glass colour in the template and adding the sizes together. Keep in mind that you need to buy around 25% extra when a project only has straight lines and up to 50% extra to make sure you have enough when a project has curves.

I keep as much of my leftover glass as possible and sort them by size and colour, ready to reuse.

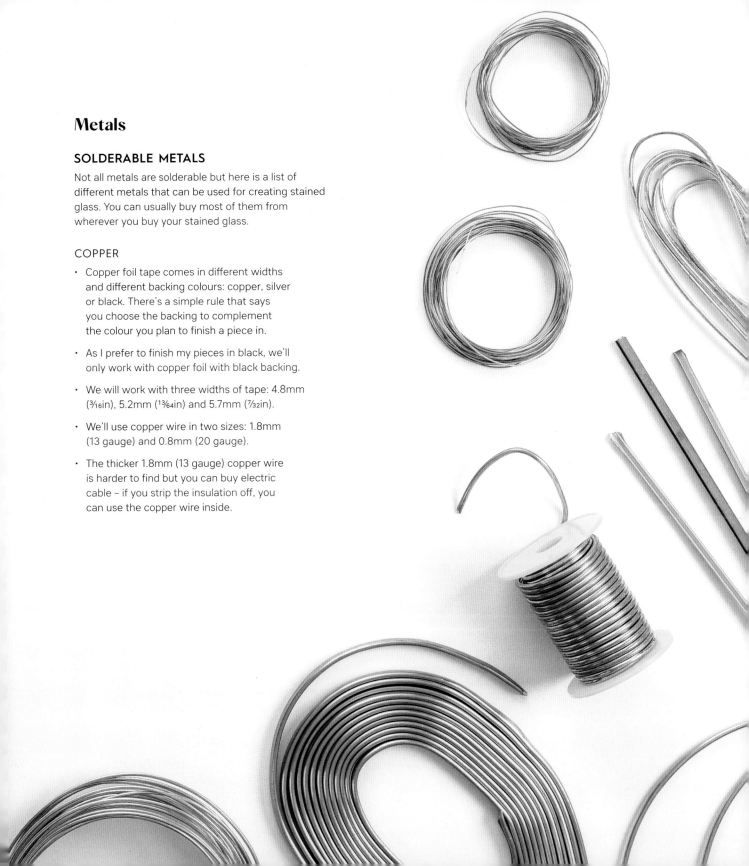

Metals

SOLDERABLE METALS

Not all metals are solderable but here is a list of different metals that can be used for creating stained glass. You can usually buy most of them from wherever you buy your stained glass.

COPPER

- Copper foil tape comes in different widths and different backing colours: copper, silver or black. There's a simple rule that says you choose the backing to complement the colour you plan to finish a piece in.

- As I prefer to finish my pieces in black, we'll only work with copper foil with black backing.

- We will work with three widths of tape: 4.8mm (³⁄₁₆in), 5.2mm (1³⁄₆₄in) and 5.7mm (⁷⁄₃₂in).

- We'll use copper wire in two sizes: 1.8mm (13 gauge) and 0.8mm (20 gauge).

- The thicker 1.8mm (13 gauge) copper wire is harder to find but you can buy electric cable – if you strip the insulation off, you can use the copper wire inside.

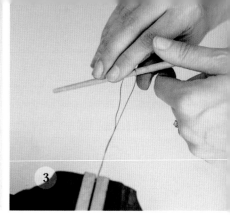

BRASS

- We will use two sizes of round brass tubes: 2mm (³⁄₃₂in) and 4mm (⁵⁄₃₂in).

- Brass U-channel comes in two sizes for stained glass but we will only use 4mm (⁵⁄₃₂in).

- Brass H-profile is 4mm x 4mm (⁵⁄₃₂in x ⁵⁄₃₂in).

- You can find the above three types of brass in specialized modelling shops or art stores where they sell materials for architects to make models.

- We'll use brass wire in two sizes: 1.8mm (13 gauge) and 0.8mm (20 gauge). For some projects, we might use copper wire instead of brass since copper is softer and easier to flatten.

PEGS

- You can make small pegs (or suspension eyes) by bending wire around bent nose pliers (see images 1 and 2). I use brass or copper wire for making pegs, and they are often tinned before bending (see How to Solder). Brass or copper wire for pegs can be 1.8mm (13 gauge) and 0.8mm (20 gauge).

TWISTED WIRE

- You can make twisted wire by taking around twice the required length of 0.8mm (20 gauge) brass wire. Bend it in two and place the loose ends in a vice. Insert a pencil or brush at the other end and start to turn until you achieve the look you're after (see images 3 and 4).

GALVANIZED STEEL

- Galvanized steel is steel covered with a thin layer of zinc. Zinc is one of the solderable metals, so it is this thin layer that makes the wire usable.

- Galvanized steel wire suitable for use with stained glass comes in three sizes: 1mm (18 gauge), 1.8mm (13 gauge) and 2.4mm (11 gauge). Garden centres are usually the best place to find these.

- A galvanized steel hoop of 20cm (8in) is used for the Poppy Suncatcher but you can find hoops up to 50cm (19¾in).

LEAD

- I use round U-lead came that measures 2mm (³⁄₃₂in) at the face with a channel of 4mm (⁵⁄₃₂in).

- Lead came is the best option for outside borders with round or curved objects since it is bendable.

- Before starting to work with lead, you need to stretch it. Lead is a soft metal, so stretching it helps to straighten it and pull out any lumps or bumps; this makes it sturdier. You can stretch lead using a vice or a lead came stretcher (see image 5). Cut the lead to size after stretching. Always wear gloves and wash your hands afterwards.

- The round U-lead has a small inner measurement, so depending on the thickness and structure of the glass used, it might be necessary to open up the lead with a fid (see image 6).

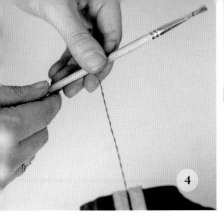
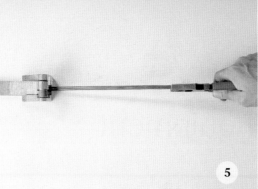
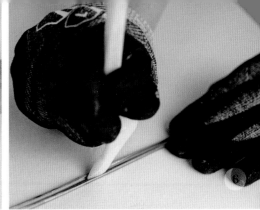

TIN SOLDER

- Tin solder (60 tin/40 lead) is the most used alloy to solder with. 50/50 solder is a bit cheaper, but it doesn't flow as well as 60/40. You can buy tin solder on a roll and as rods. Lead-free solder is also available. It's an alloy of tin, copper and silver but it is harder to work with and due to the silver, very expensive. I only recommend using it for jewellery.

NON-SOLDERABLE METALS

CHAINS AND SPLIT RINGS

To hang your pieces, you can use different kinds of chains. Chains sold at stained-glass stores are often very chunky, so I look for them at craft shops or at jewellery suppliers. You can also find various sizes of split rings there too. Always use two pairs of pliers to open and close the split rings.

Chemicals

When using these products be sure to wear gloves! Make sure you dispose of these products according to the law in your country.

ABRASIVE CREAM CLEANER

I use this type of cleaner (such as Cif) to clean my pieces as it has a light abrasive effect and prepares the solder lines for the patina. Make sure you rinse it off properly with lukewarm water. After applying patina, I use regular washing up liquid (dish washing soap) for the final rinsing.

FLUX AND FLUX BRUSH

This fluid makes the solder run smoothly. I prefer to use acid-free soldering fluid. You'll apply it on the copper with a brush.

GLASS CUTTING OIL

This is a lubricant – it helps with breaking the glass and it extends the life of your glass cutters.

PATINA

You can leave your solder lines silver coloured, but I mostly use black patina because I like the way it looks – patina is the chemical that turns the silver to black. There are different shades available, such as copper, for you to try. You can apply patina with a soft brush, a toothbrush or a cotton swab.

ANTI-OXIDATION SPRAY

A special product that is available as a liquid and as a spray. You'll apply it after applying patina. It prevents further oxidation of the metal parts.

Tools and Equipment

In addition to the glass and the different metals you can use, there are a few other essential tools that you will need for creating stained glass. There are two tools you will need that are a bit more expensive and that's the grinder and the soldering iron.

Craft knife

Any small knife with a sharp blade will do. You'll need it to adjust or remove copper foil tape. I also use it to smooth the copper foil tape onto the glass.

Fid

This is a simple plastic or wooden tool used to open lead or to smooth the copper foil onto the glass.

Glass cutter

There's an extensive range of glass cutters on the market. My main advice is to pick one with an oil reservoir. You can use petrol or a special glass cutting fluid – just don't mix them.

Cutters come with a narrow or a wide head and your preference may depend on how you hold the cutter. If you want to be sure, just go to your local stained-glass shop and try some different models.

CIRCLE CUTTER

You can cut circles by hand, but a circle cutter is a nice addition to your toolset. The regular models don't have an oil reservoir. They come in different sizes and are attached to the glass with a sucker.

Gloves

I like to wear my work gloves all the time but when working with fluids I switch to latex gloves.

Grinder

A bit like sandpaper but for glass, you'll use the grinder to adjust the cut glass pieces to get them to fit closely together. It will also roughen up the edges of each glass piece so the copper foil will stick better.

There's a vast range of grinders on the market with quite a price difference between them. If you have a little patience, you can quite often find one second-hand.

Grinders come with different sized bits, from 3mm to 2.5cm (⅛in to 1in) and different grits. I mostly use the 2.5cm (1in) bit with an average grit.

Hammers

I use a regular metal hammer to flatten metals and a rubber one when working with U-lead came. A rubber hammer prevents the metal from being damaged.

L-square

To cut straight lines, you'll need an L-square. They come in different sizes but for the projects in this book a 30cm (12in) L-square will suffice.

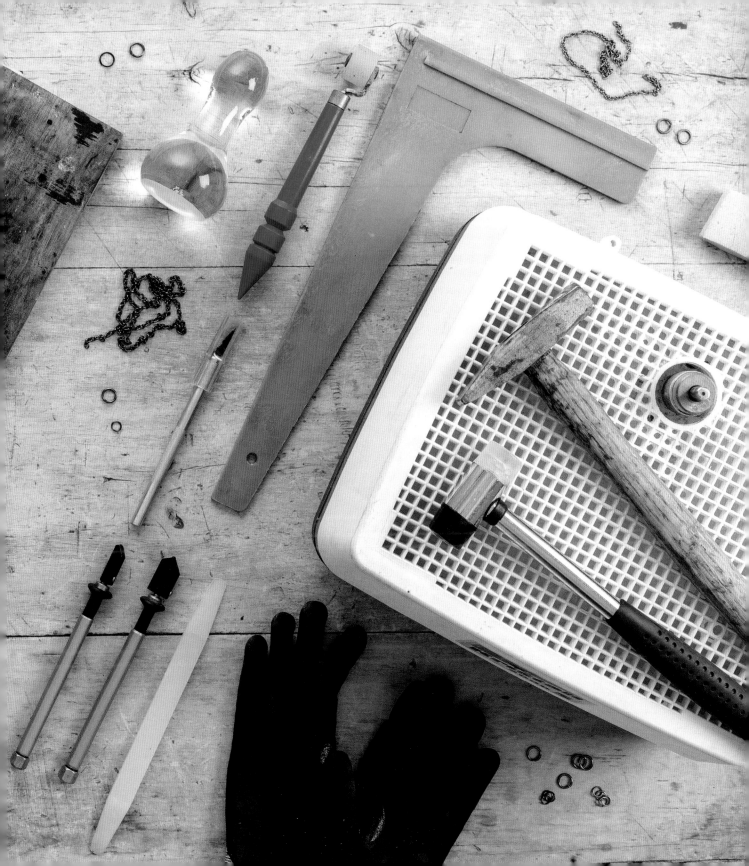

Markers

You will need a black and a white permanent marker for tracing designs onto glass. It's important that you use waterproof markers as the lines still need to be visible while grinding.

Metal saw

I use a small metal saw to cut brass H-profile to size or if brass tubes need to stay open at the ends.

Paper

I use two kinds of paper to transfer templates onto glass: tracing paper and carbon paper.

Pliers

BENT NOSE PLIERS

These are my favourite pair of pliers. I use them to cut and bend wire, and to hold metal parts in place while I'm soldering.

CUTTING PLIERS

These are used to cut all kinds of wires and tubes.

GRINDING PLIERS

If you want to keep your fingernails and not lose them to the head of the grinder when working with small pieces, I recommend you use grinding pliers. There are a number available from different brands.

GROZIER PLIERS

These pliers are used to break off small pieces of glass or to correct badly broken pieces (grozing) in a controlled way.

LIL NOTCHER OR TIN SNIPS

The Lil Notcher are special pliers that cut little triangles out of brass U-profile so you can bend the brass at a perfect angle. If you don't have these pliers, you can do the same with tin snips.

RUNNING PLIERS

With these pliers, you can help a score to break or run.

Razor blade

A sharp single-edged razor blade is used to remove any excess mirror protector or nail polish after it has dried.

Safety glasses

A pair of good safety glasses are essential to protect your eyes from tiny fragments of glass or solder. If you do get anything in your eye, seek medical help as soon as possible.

Scissors or pattern shears

You'll need scissors to cut out the different templates and to cut copper foil to size. Special pattern shears are available, but I only ever use sharp kitchen scissors.

Soldering iron with stand

I use a 100W Weller iron for all my projects but an 80W iron is the minimum that's required for soldering stained glass. Most irons have a built-in temperature controller. There are different tips available for each brand of irons. I prefer to use one with a flattened side (sometimes called a chisel or D-series tip) not the pointy ones. If your iron becomes too dirty you can clean it with a wet sponge.

You will need a stand for your iron as you can't just put the iron on your work surface due to the risk of burns. However, most irons come with stands.

Vice or lead stretcher

A tool used to keep something in place. I also use a part of my vice to 'forge' items from copper or brass. You can also use it to stretch the U-lead for some projects if you don't have a lead stretcher.

Wooden board with L-square

I always advise working on a wooden surface. A small wooden board with two smaller pieces of wood fixed as an L-square is an easy way to make sure that a project has straight lines. For the projects in this book, a board with a working surface of 35cm x 35cm (13¾in x 13¾in) will be fine.

Extra tools for painting

BRUSHES

I like to use brushes with long bristles. It might take some practice but it's the best way to make long straight lines.

GLASS PAINT

Traditional glass paint, or grisaille, comes in powder form to be mixed with water. After mixing the paint, be sure to cover it so nothing falls into it.

PALETTE KNIFE OR GLASS MULLER

Grisaille glass paint needs to have a thick texture like paste. A palette knife or glass muller will help you create this.

PORCELAIN MARKER

Traditionally, paint is set by being fired in a kiln. As not everybody owns an expensive kiln, you can use a black porcelain marker by Marabu, and I think it makes a good alternative. Just follow the instructions on the pen. We'll only use the colour black in these projects.

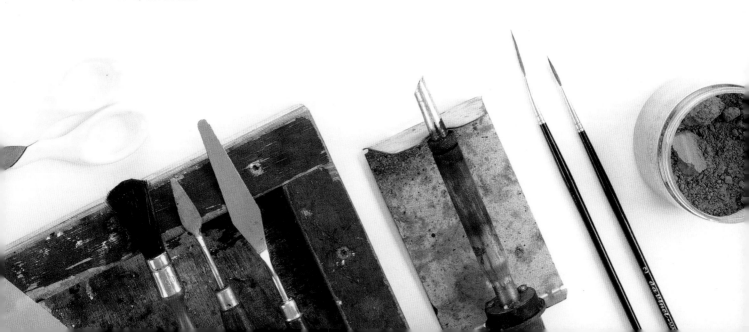

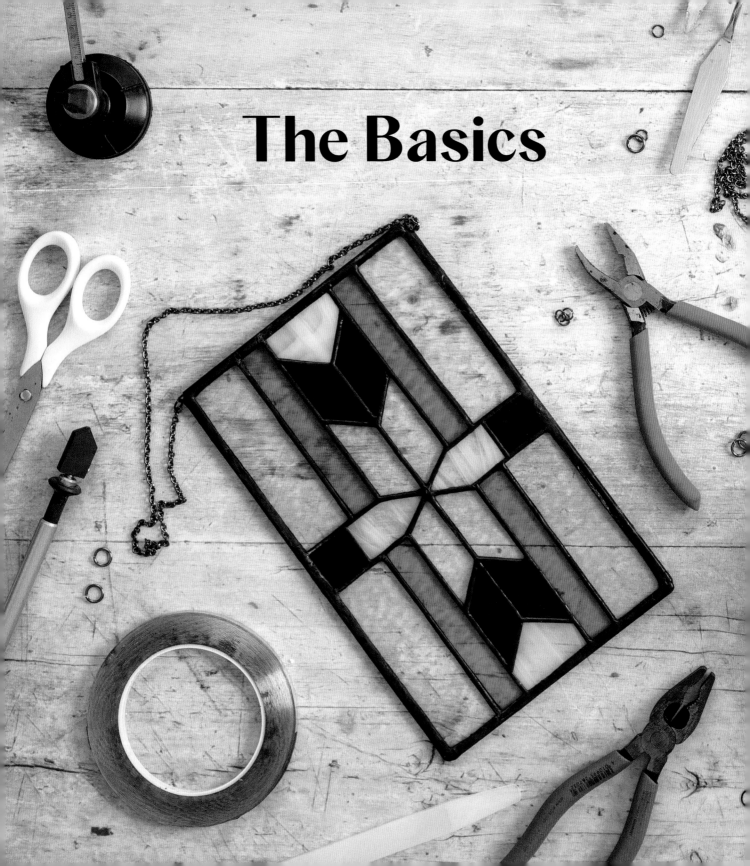

The Basics

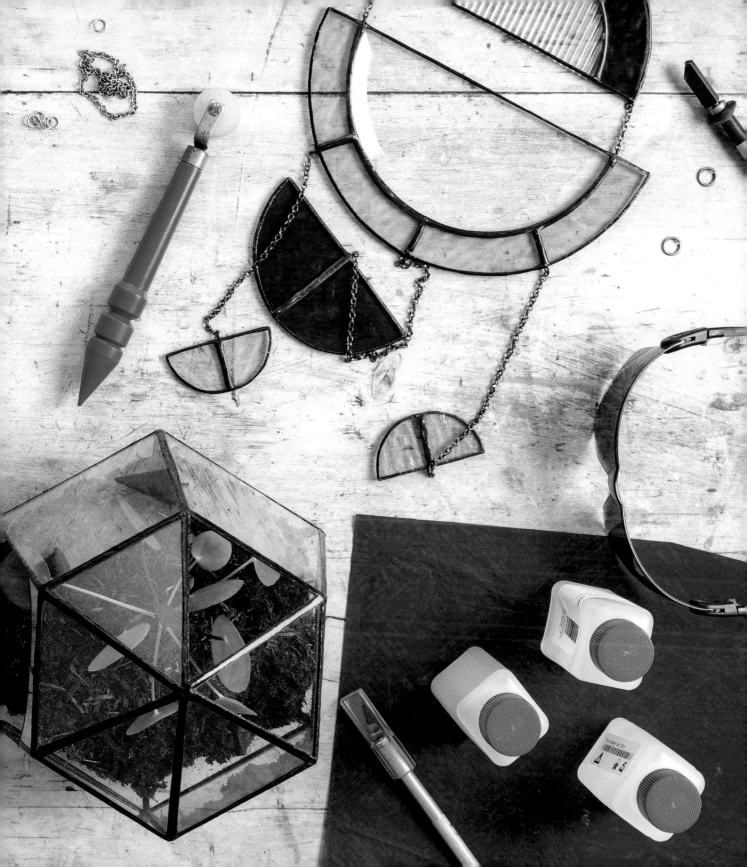

Setting Up Your Workspace

When you're making stained glass, you'll work with metals like lead and some chemicals. Taking the time to properly set up your workspace and consider some basic safety measures will help to avoid accidents.

Spend some time finding the perfect place for your workspace in your home. Some projects might take a while to make, so consider a spot where you can leave your setup for longer periods. Make sure you have enough light, as some of the pieces you'll work with are tiny.

Ventilation and an easy-to-clean floor are a must. You'll also want access to water nearby for grinding and cleaning your projects.

I prefer to work on a wooden surface for cutting glass, but some felt or a rubber mat also works. For soldering, I recommend making a wooden board with an L-square attached to it (see Tools and Equipment).

I like to stand when cutting glass but when wrapping, painting or soldering I prefer to sit down. You'll soon figure out what works for you.

Always have a dustpan and brush to hand to keep your workspace clean: small splinters of glass or small drops of solder can cause scratches and even fractures.

Once you get the hang of soldering and you plan to do it more often, it might be worth considering buying a smoke absorber or fume extractor. These are far more effective than just opening a window.

When making stained glass there are some safety measures that you need to keep in mind:

- The most obvious one is probably that, given you are working with glass, you should wear your work gloves all the time.

- 'The gloves will protect your hands from cuts (especially your fingers when grinding) and from burns when soldering.

- Wear safety glasses when cutting and grinding glass as small fragments might fly around. You do not want to get anything in your eyes.

- Wear a mask when grinding glass to stop you from breathing in too much dust, although the water you have on hand when grinding will also help.

- Wear an apron and closed shoes. I prefer to wear jeans, but all natural fibered clothes will do. Sometimes small balls of solder can fall and if you're wearing synthetic clothes you might burn yourself.

- When working with acids like flux and patina you should wear latex gloves to avoid direct skin contact. I often wear them under my work gloves while soldering.

How to Transfer Templates

All the templates that you need for the projects in this book are in the Templates section. Note that some of the templates will need to be traced twice and used as a mirror image to make the complete template. These projects are: Square Panel, Round Panel and Snowflake with Bevels. Textured glass sometimes has a rough side and a smooth side, and sometimes two smooth sides. Templates are always traced onto the smooth side of the glass.

Tools & Materials

- Tracing paper
- Carbon paper
- Scissors
- Ruler
- Permanent markers in black and white
- Pencil

1. Copy the template onto tracing paper with a pencil. You can trace a template free-hand but if it contains straight lines, then it's best to use a ruler. Number the pieces if necessary. I like to add colour codes as well especially for more complex designs.

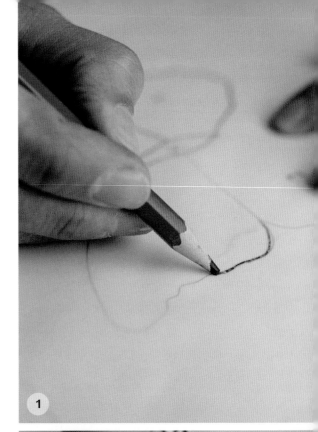

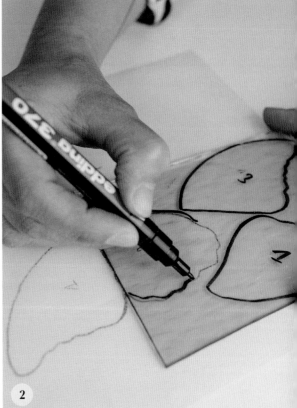

2. Trace the pieces of the template that are of the same glass colour directly onto transparent glass with a black permanent marker. If your glass has a design on it, you can pick the best position for each piece.

3. If you want to transfer a template onto a light-coloured opaque glass, you can use carbon paper.

4. For darker coloured glass, cut out the template and trace it with your white permanent marker or you can cut directly around the template.

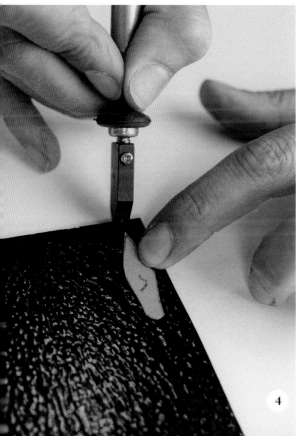

How to Cut Glass

Although we talk about 'cutting' glass, it's not really cutting. You are creating a scratch with a glass cutter, the glass is weakened in that spot and therefore breaks more easily. When working with textured glass, always check which side is the smooth side of the glass. This is always the side you will cut on. A clean working surface is vital, as little leftover shards of glass or other bumps can cause scratches and even the glass to break in the wrong place.

Tools & Materials

- Glass cutter
- Circle glass cutter
- Cutting oil
- L-square
- Running pliers
- Grozier pliers

Curves

1. Curves are cut free-hand. Keep in mind that the cutting wheel in a glass cutter isn't positioned exactly in the middle of the head but 2mm (³⁄₃₂in) to the side of the head. You can pull or push the glass cutter depending on what works for you. After a few goes, you'll know what way feels most comfortable. Never go over a score or you'll damage the wheel. You'll learn to recognize the sound when a score is made.

2. If a curved score is well made you can break it by hand or with grozier pliers. You might need to tap the underside of the score gently with the back of your glass cutter if it didn't run all the way through.

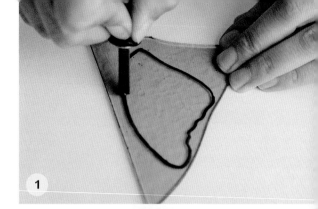

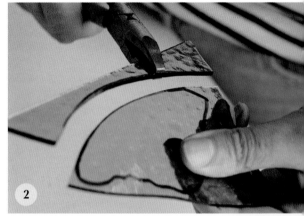

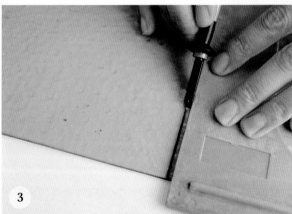

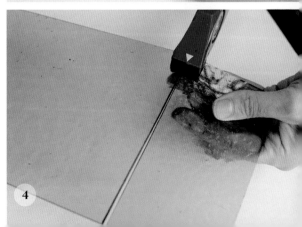

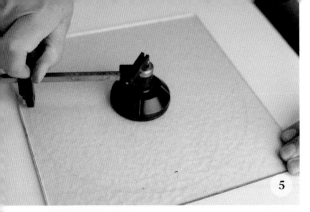

5

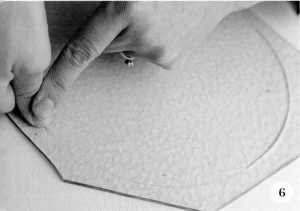

6

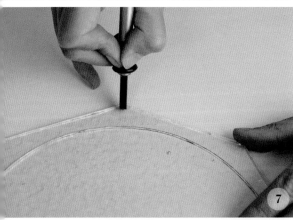

7

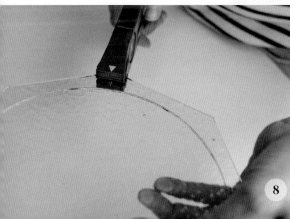

8

Straight lines

3. To cut straight lines, always use an L-square even for small pieces. Pull the glass cutter towards you and run along the L-square in one movement.

4. Use the running pliers to break the score. To do this, put the arrow or stripe on the score and gently push. If the score doesn't break, you might need to tap the underside of it gently with the back of your glass cutter and try again.

Circles

5. You can cut circles by hand but you'll get the best results with a circle cutter. If yours doesn't have an oil reservoir, you should first dip the glass cutter wheel into cutting oil. Adjust the circle cutter to the right size, remembering the numbers on the cutter indicate the diameter of the circle. Make sure the sucker is well attached to the glass and that you have left a space of around 1cm (½in) so the circle fits onto the glass.

6. After cutting the circle, take the edges off the glass to make it easier to reach the score. Turn the glass around and gently push on the score so you can see it run through. You will notice the light refraction change. If it doesn't run completely through, you can gently tap the underside of the score with the back of your glass cutter.

7. If you are sure the score has run through around the whole circle you can make some small cuts from the outside of the glass towards the circle. Stop 2mm to 3mm (³⁄₃₂in to ⅛in) before you reach the score.

8. Take your running pliers and gently push. You'll see the excess pieces come off. You can use the grozier pliers to remove any little pieces of glass that didn't come off.

How to Grind Glass

Grinding is important as it allows all the pieces of glass to fit together snugly, like a puzzle, and allows the copper foil tape to stick to the glass. You are looking to create a smooth edge and to correct any imperfections in the line of the cut piece, just like using sandpaper. When grinding large quantities, it can feel like a drag but it's an essential step in the process. The better your pieces fit together, the better the result. Make sure you wear your work gloves, safety glasses and a mask.

Tools & Materials

- Grinder
- Grinding pliers
- Work gloves
- Safety glasses
- Mask
- Chapstick

1. Grinding isn't a very difficult job, it's more a question of patience. Make sure there's enough water in the grinder and that the sponge or brush is wet and in the right place. This will keep your glass piece cool, and it will prevent you from inhaling a lot of fine glass powder dust.

1

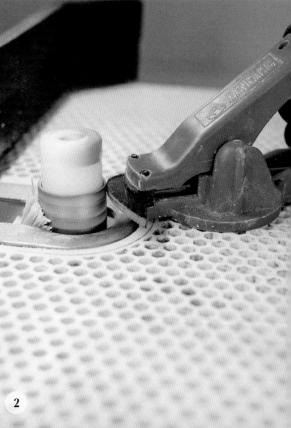

2

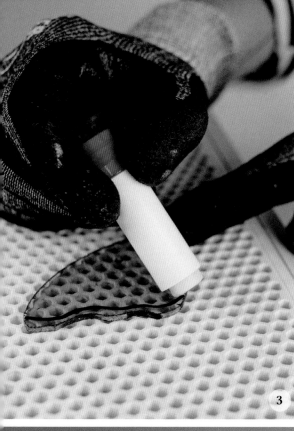

2. There are different grinding pliers available for grinding small pieces and these are useful for protecting your fingers.

3. Clean all your glass pieces thoroughly after grinding otherwise the copper foil won't stick. I like to have a bowl of water ready for the finished pieces so the dust from the grinding doesn't dry onto them. If the permanent marker used to mark the pieces rinses off too fast, cover it with chapstick, as it will then stay on much longer.

4. Every brand has grinder heads available in different sizes and they are easy to swap. They go from 3mm (⅛in) up to 25mm (1in).

If you're working on a complex design and the numbers used to identify the pieces wash off, put your pieces back on your template straight away while you still remember which piece goes where.

How to Paint Glass

The technique I'll explain here has been used for painting on glass for centuries. However, you need a kiln to be able to fire the paint. As not everybody owns an expensive kiln, I've tested a black porcelain marker by Marabu and I think it's a good alternative. Just follow the instructions on the pen.

Tools & Materials

- Clear glass pane
- Palette knife or glass muller
- Glass paint in black contour grisaille or black porcelain marker by Marabu
- Pipette
- Brushes

1. Traditional grisaille glass paint comes in powder form and must be mixed with water. Use a pipette to add drops of water at a time so you have more control. I always work on a clear glass pane.

2. You will need to achieve a paste-like texture by grinding the mixture on a glass surface with a palette knife or a glass muller. Always cover your paint to avoid dust falling into it.

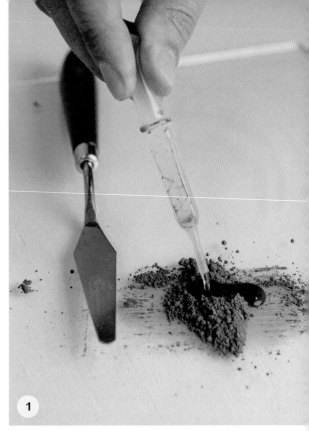

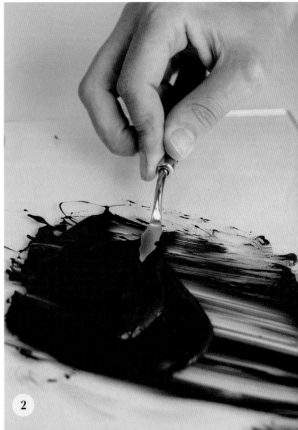

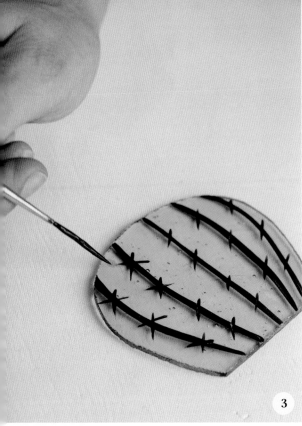

3

3. Always make sure your glass is clean before you start. Painting on glass might take some practice but it has one advantage: it's very easy to wipe off and start over again. You'll need to figure out which brushes create the effect you're after. I use long-bristled brushes for long smooth lines and short-bristled brushes for dots.

4. After painting the pieces, make sure the back is clean. The painted pieces in this book aren't big and they won't be fired again so you can just fire them for 10 minutes at 620°C. Keep the kiln closed until they have cooled down.

When your lines are not what you want, you can always correct them by using a calligraphy pen.

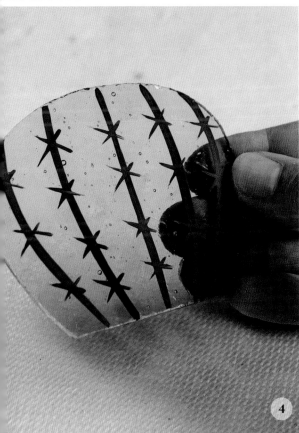

4

How to Foil Glass

Foiling is an essential step in the process and might take a little practice. You need to cover the sides of the glass with copper foil so you can bond the pieces together with solder. Solder doesn't stick to glass but does to copper. There are several tools available for foiling, but after trying them all out, I think foiling by hand works best, especially for smaller pieces.

Tools & Materials

- Copper foil tape
- Scissors
- Craft knife
- Fid

1. Never start your foiling at the corner of a piece. Instead, start a couple of centimetres (an inch or so) away from the corner as this will make it easier. If possible, keep in mind what pieces will be attached together and start by foiling these inside joins. If you have an inside curve, that's definitely the place to start.

A little trick for small pieces is that you can foil them and secure the foil by shaking the pieces in a little plastic box. You still might have to adjust the copper foil with a craft knife.

2. Try to position the foil in the middle of the glass so that, when folded, the edges are equally covered. The start and the end of each piece of foil must overlap perfectly.

3. Use a fid to bend the foil onto the glass.

4. Use a craft knife to make sure that all the foil lines are smooth. You can also use the knife to trim away excess copper foil where it overlaps too much. If you have a crack in the foil, you can cover it up with a small piece of copper tape. If you're not happy, just take off the copper tape and start again, as good foiling is essential.

Don't wait too long to solder your pieces after foiling as a green oxidation layer will appear on the copper foil that will make soldering more difficult.

How to Solder

Soldering is how we join pieces of glass together once they have been copper foiled. Always solder in a well-ventilated space. You can wear work gloves to avoid burns and wear some latex gloves underneath to avoid contact with the flux. I prefer to work on a wooden board to protect the surface underneath from burns.

Tools & Materials

- Wooden board
- Soldering iron with stand
- Flux with flux brush
- Tin solder
- Work and latex gloves

1. Always start with brushing flux onto the copper lines. Without flux, the solder will not run smoothly. You can always add more flux if you notice that the solder is getting sticky.

2. The first step is tack soldering – attaching the pieces of glass together using a drop of solder to hold the pieces in place. First, heat the iron until it's hot enough to melt the tin solder. Take a rod of solder and melt it onto the copper foil that has been brushed with flux. The solder will only stick to the copper not the glass. Solder stays liquid for a couple of seconds before it cools and becomes solid, and you'll learn to spot the colour difference when this happens.

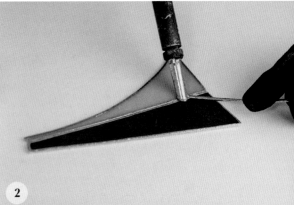

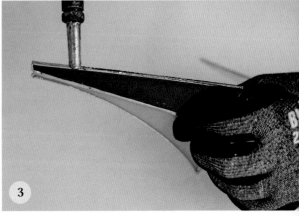

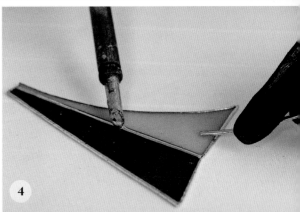

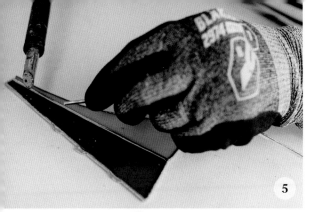

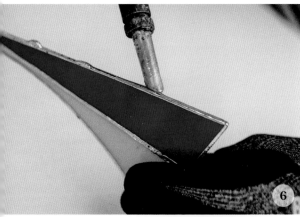

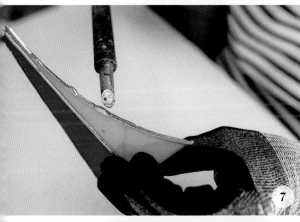

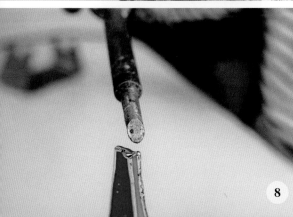

3. Step two is tinning – applying a thin layer of solder along all of the copper foil both on the inside lines and on the edges. I always tin the whole piece. Always hold a piece to tin the edges so you can see what you are doing. Copper or brass used for wire details and pegs should also be tinned.

4. Step three is beading. Here you are creating smooth but thick solder lines with nice round edges by using a lot more solder than for tinning. You also need to work more slowly because of the extra solder.

5. Beading the edges is very important for two reasons: you'll seal the copper foil to the piece and it gives a much better finish. If a piece is to be fitting with brass U-channel, you'll only tin the edges not bead them, so the U-channel will still fit. Start by dropping some 'beads' of solder on the edges while the piece is still laying flat on the work surface.

6. Lift the piece and keep it level. Tap the sides gently with the soldering iron. You are looking to keep as much solder on the edges as possible, as this gives you the best beading. Excess solder will fall off so wear work gloves.

7. A curve is a little harder to bead but always try to keep the glass level. Use the fluidity of the molten solder to your advantage. Remember to hold a piece when beading its edges.

8. Make sure to bead all the lines properly for the best result. Always check the back after soldering as the reheated solder might have run through. Clean the piece as soon as it's finished.

How to Finish a Project

When you're happy with the result of your soldering, it is time to clean the piece thoroughly. Soldering flux is an acid and must be removed.

Tools & Materials

- Abrasive cream cleaner
- Washing up liquid (dish washing soap)
- Latex gloves
- Patina
- Brushes or cotton swabs
- Anti-oxidation spray

1. Fill a container with water. Clean the project pieces with water and abrasive cream cleaner. This will prepare the solder lines for the patina. Rinse off with clean water.

2. Wipe the project dry and apply the patina with a brush to the soldering. Make sure all the soldering is covered. Always wear latex gloves.

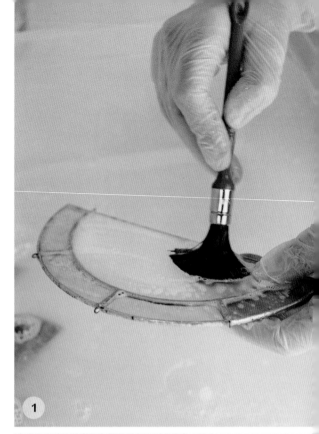

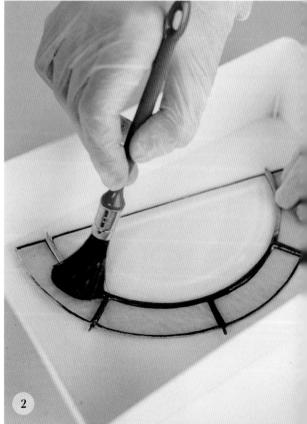

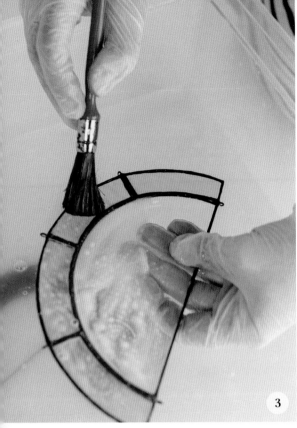

3. Wash the piece with washing up liquid and make sure it is completely dry afterwards, as the anti-oxidation spray applied in the next step will not stick if the piece isn't completely dry. Make sure you dispose of the water according to the law in your country.

4. Spray the piece with anti-oxidation spray in a well-ventilated room. Leave it on for at least 5 to 10 minutes before you rinse it off. For designs with wired details, I sometimes use a hairdryer to make sure the anti-oxidation spray gets into every corner.

Some specific types of Bullseye Glass reacts with patina so when working with this brand, be very careful when applying the patina.

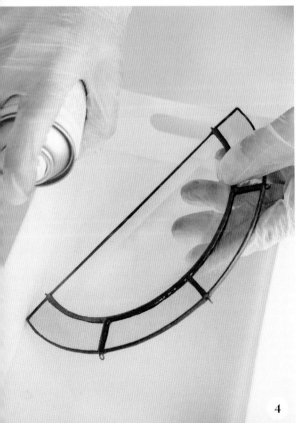

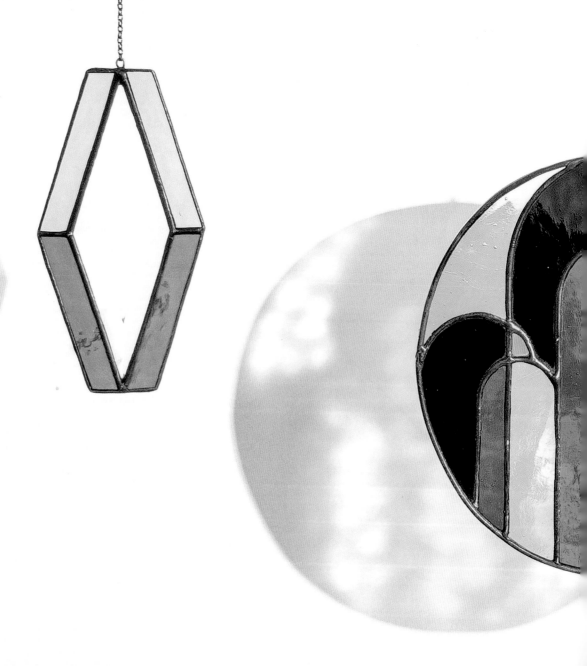

The Projects

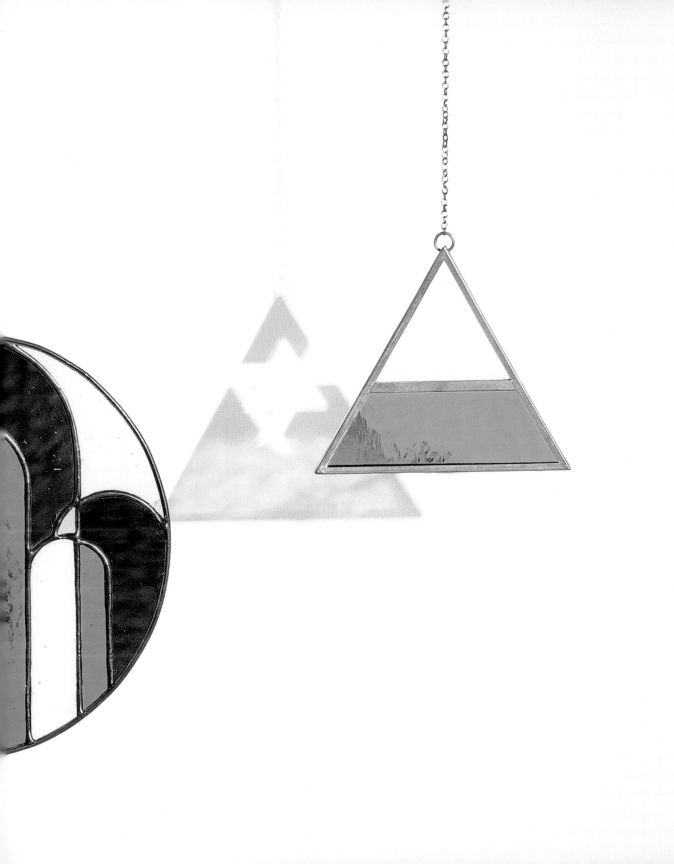

Diamond Suncatcher

A classic design to start with and a great way to learn how to cut straight lines with an L-square. Bevelled glass acts as a prism when the sun shines through it, so it will send rainbows all around the room.

Glass

- Oceanside Dark Amber Rough Rolled Fusible 111RR
- Oceanside Sea Green Rough Rolled Fusible 528-1RR
- Diamond Bevel (5cm x 15cm/2in x 6in)

Tools & Materials

- 5.2mm ($1\frac{3}{64}$in) copper foil tape with black backing
- 2.5cm (1in) of 1.8mm (13 gauge) brass wire
- 50cm (19¾in) of black metal chain
- 1 x 10mm (⅜in) black split ring

Difficulty rating: Easy

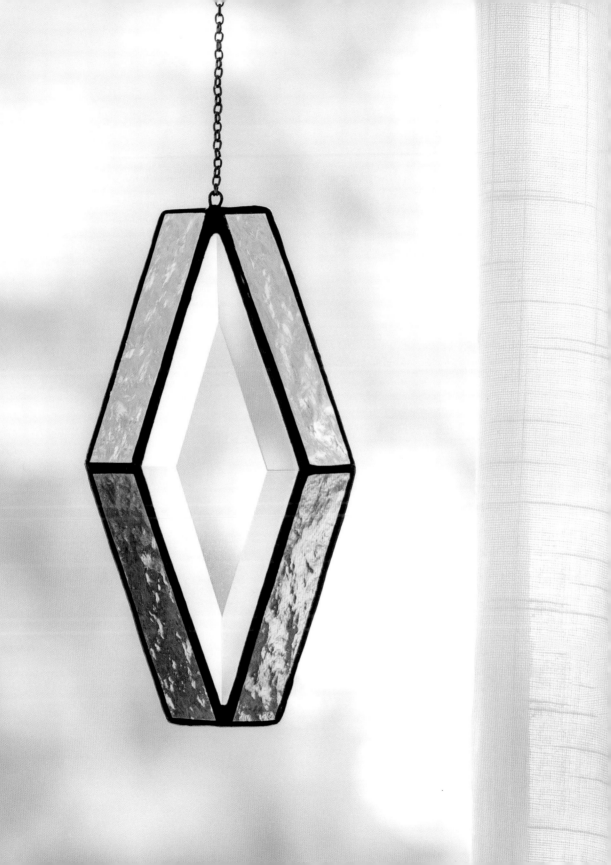

1. Start by tracing the template from the Templates section. As we are working with all transparent glass in this project, this should be nice and straightforward (see How to Transfer Templates). Cut the glass as shown in the template (see How to Cut Glass).

2. Grind all the pieces, including the diamond bevel (see How to Grind Glass). As the bevel isn't level, make sure to place the flat side on the grinder surface.

3. Foil all the pieces (see How to Foil Glass).

4. Adjust the foil lines with a craft knife, if needed.

5. Use bent nose pliers to make a peg (see Materials: Pegs) with the brass wire. You can tin the wire before or after bending the peg.

6. Apply flux and tack solder all the pieces and the peg in place , as shown by the red arrow on the template (see How to Solder). Next you can tin the whole piece.

7. Beading the copper lines on the suncatcher itself and on the edges of the piece will give it a nice, finished look. Beading the edges is important as the copper foil tape will come off if you don't apply enough solder.

8. After checking the piece thoroughly, it is ready to be finished (see How to Finish a Project). As the final step, attach the black chain to the peg and a split ring at the top to hang the suncatcher.

If you don't have a diamond bevel, you can use some structured transparent glass instead.

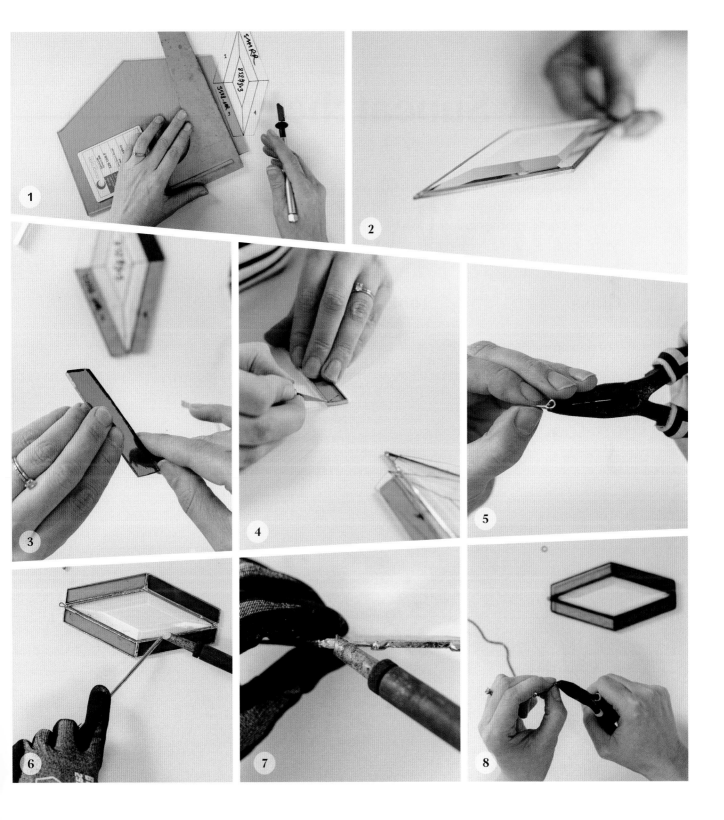

Poppy Suncatcher

This elegant design is created by using a hoop and just the right amount of wire detail. Did you know that poppies come in other colours too? Try them in orange, white, pink or purple.

Glass

- Wissmach 90-10 Orange Red
- Any small leftover piece of green glass

Tools & Materials

- 5.2mm (13⁄64in) copper foil tape with black backing
- 40cm (16in) of 1.8mm (13 gauge) copper wire
- 20cm (8in) of 0.8mm (20 gauge) copper wire
- 1 x 20cm (8in) galvanized steel wire hoop
- 50cm (19¾in) of black metal chain
- 2 x 10mm (⅜in) black split rings

Difficulty rating: Medium

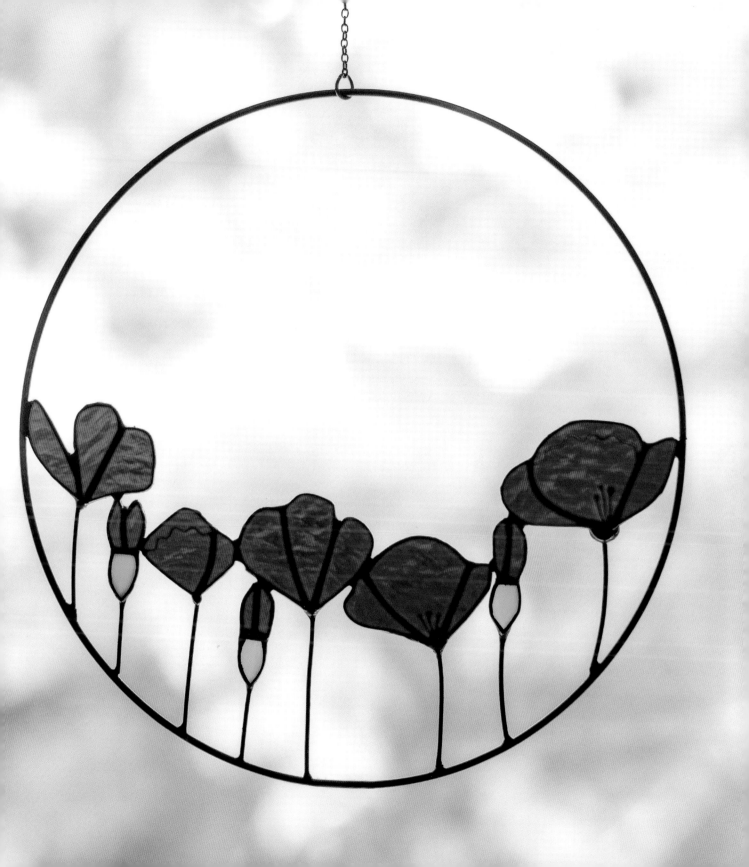

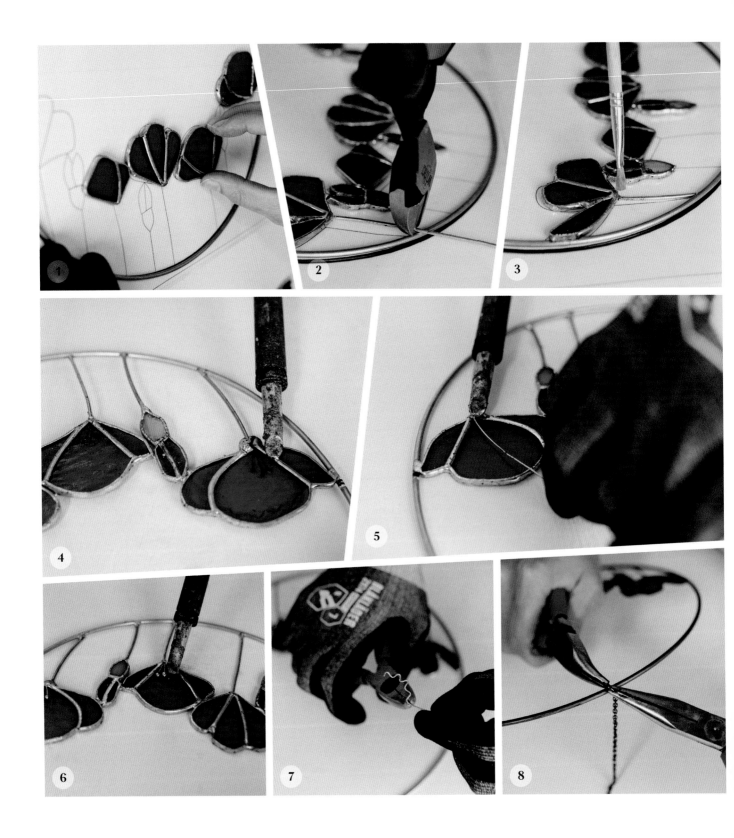

1. Start by tracing the template from the Templates section (see How to Transfer Templates). After cutting, grinding and foiling the glass, solder the poppies together (see The Basics). Next, position the poppies inside the hoop according to the template.

2. For the stems, take pieces of 1.8mm (13 gauge) copper wire and tin them (see How to Solder). Cut every stem to size with some cutting pliers.

3. Apply flux and solder one end of every stem to the hoop and the other end to the flower.

4. After finishing the front, solder the back of the piece. Check the solder lines and the points where the wire connects to the flowers and the hoop.

5. For the smaller stamens, use the thinner 0.8mm (20 gauge) copper wire. Just as before, start with tinning them. Attach three wires to the centre of the poppy to create stamens and use cutting pliers to trim them.

6. Finish the stamens off with a little drop of solder to create a tiny ball at the end. This might take a little practice. If you find it easier, you can make the stamens first and attach them to the centre of the poppy afterwards.

7. For some extra detailing, use the tinned 0.8mm (20 gauge) copper and bend it with bent nose pliers into a zigzag pattern. Attach this zigzag wire to both sides of the central petal of the poppy.

8. After checking the piece thoroughly, it's ready to be finished (see How to Finish a Project). As the final step, attach the black chain to the hoop using the split rings.

If you find it difficult to attach the stamens, wait for the solder to completely cool down before you try again.

Angular Terrarium

Don't we all just love plants? You don't always have to use a planter – this little terrarium is a real eyecatcher. For this project, you only need some leftover clear glass and that makes it even better.

Glass

- Clear glass between 2mm to 3mm (³⁄₃₂in to ⅛in) thick

Tools & Materials

- 5.2mm (¹³⁄₆₄in) copper foil tape with black backing
- Self-adhesive rubber feet

Instead of buying glass for this project, I use recycled glass from old photo and picture frames to make the terrarium

Difficulty rating: Hard

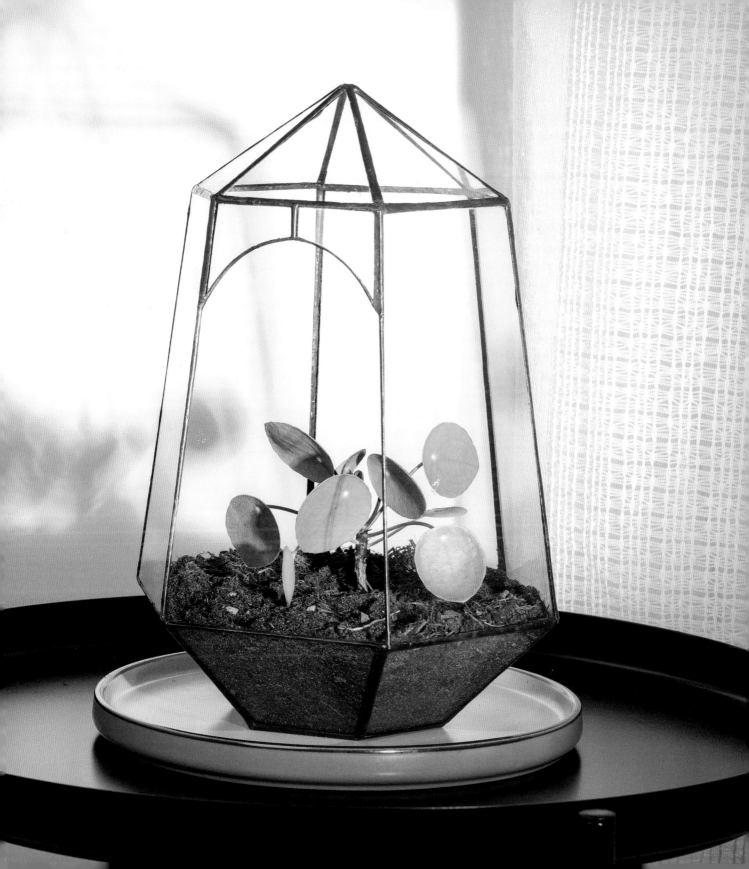

1. Start by tracing the template from the Templates section (see How to Transfer Templates). For 3D projects, it's very important that the pieces fit together as tightly as possible. Cut, grind and foil all the pieces (see The Basics), except for the two small arches (numbered 4 and 5 on the template). Start to assemble the terrarium using the seven bottom pieces (2 and 3 on the template), by applying flux. I start at the bottom to make sure the terrarium is level.

2. Attach the sides to the bottom piece. Use a small drop of solder (tack soldering) so you can still adjust the angle and the position (see How to Solder). If you notice that the pieces don't fit nicely together, you should reheat the solder and reposition them until all six sides fit perfectly.

3. After finishing the bottom part of the terrarium, completely solder the inside now because after putting the upper pieces on, the bottom will be very hard to reach.

4. The next step is to connect the five big sides (numbered 6 on the template). Use the same tack soldering technique to only attach the pieces with small drops of solder at first to make sure you're able to adjust if necessary.

5. As the solder lines on the inside of the planter are very thin, the space between the pieces on the outside is larger. As a first step, only fill these gaps and make sure you cover all the copper foil with solder. You will clean up your solder lines and bead them (see How to Solder) later on.

6. Solder the top pieces (numbered 1 on the template) into place using the same technique as for the sides.

7. Solder the whole inside of the terrarium and close the top with a drop of solder. Next, check the two small arches fit together before foiling. It may be neccesary to adjust them a bit by grinding them.

8. Solder the arches together before you solder them in place. Bead all the solder lines on the outside of the terrarium. After checking the piece thoroughly, it's ready to be finished (see How to Finish a Project). You can attach some self-adhesive rubber feet to the bottom to finish off the piece.

Make sure the lower part of the terrarium is waterproof by pouring some water into it before finishing. If it leaks, you should go over the solder lines again.

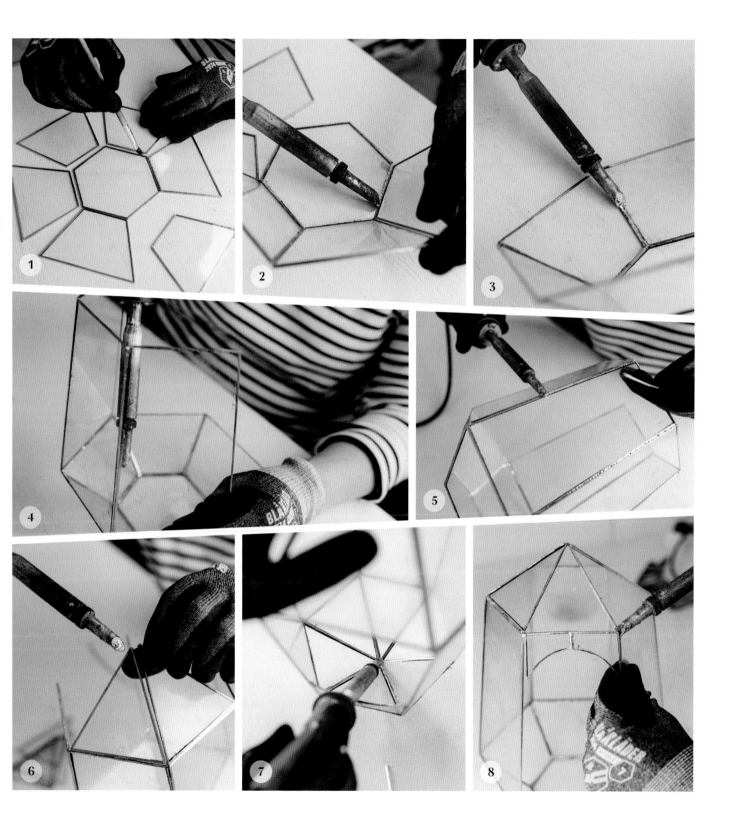

Butterflies

This project will show you how to make delicate but oh-so-colourful butterflies. It's not a complex design but the wired details are an easy way to make them stand out.

Glass

For one butterfly

- Oceanside Yellow Rough Rolled Fusible 161RR-F (yellow butterfly)
- or Oceanside Dark Blue Rough Rolled Fusible 136RR-F (blue butterfly)
- Small piece of dark glass

Tools & Materials

For one butterfly

- 5.2mm ($^{13}\!/_{64}$in) copper foil tape with black backing
- 90cm (35½in) of 0.8mm (20 gauge) brass wire
- 7cm (2¾in) of 1.8mm (13 gauge) galvanized steel wire
- 30cm (12in) of 4mm ($^{5}\!/_{32}$in) brass tube
- Steel wool

Difficulty rating: Easy

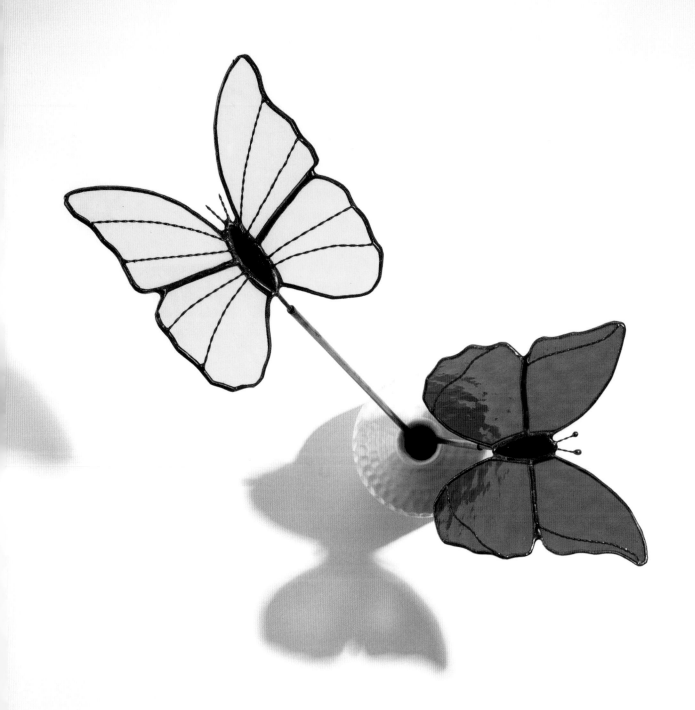

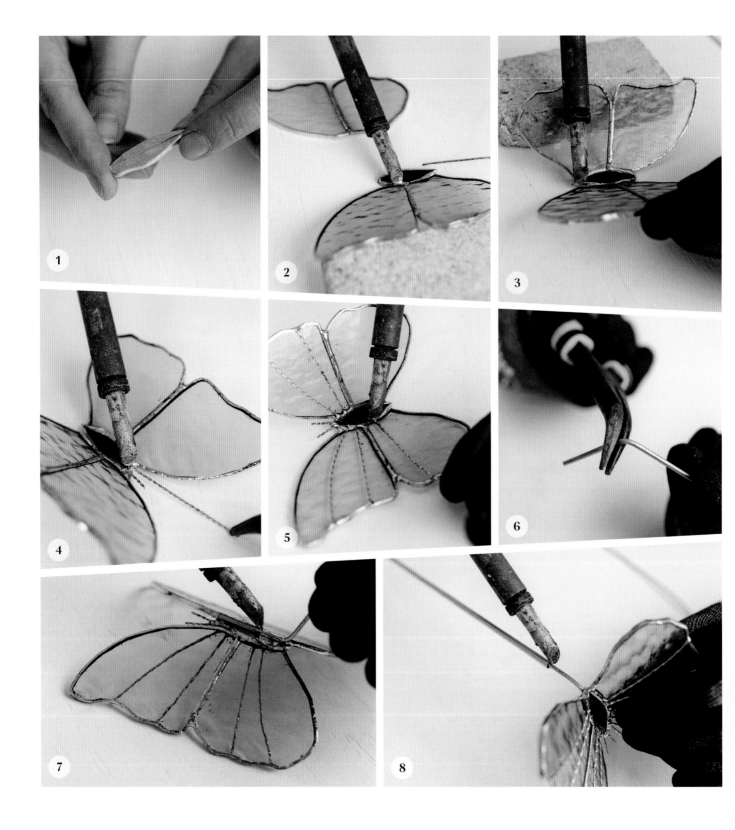

1. To make one butterfly, start by tracing the template from the Templates section (see How to Transfer Templates). Next, cut, grind and foil the five pieces of coloured glass (see The Basics). Cover the back of the butterfly's body completely with copper foil.

2. Solder the wings together (see How to Solder). To get the same angle on both wings, you can use anything that's around 2cm (¾in) thick to rest the wings on when you solder. The butterfly's body should stay flat on the surface.

3. After attaching the wings to the butterfly's body, tin the whole butterfly.

4. Next, carefully add some twisted brass wire as the antennae (see Materials: Twisted Wire). You can finish them with a little drop of solder at the top (as with the blue butterfly) or leave them plain (as with the yellow butterfly).

5. Add twisted brass wire details to the wings in any pattern that you like. Bead the inside lines and the edges afterwards so all the wires are secured.

6. Take the 7cm (2¾) piece of 1.8mm (13 gauge) galvanized steel. Measure it against the size of the body and bend the steel into almost a right angle (80°). The bent section of wire shouldn't be longer than the body, as otherwise it will stick out.

7. Solder the galvanized steel wire on to the back of the butterfly's body, making sure to place it down the centre. Insert 1cm (⅜in) of the galvanized steel wire into the brass tube.

8. Fix the steel wire and brass tube together with a drop of solder, although getting the wire in the right place might be a little tricky. After checking the piece thoroughly, it's ready to be finished (see How to Finish a Project). Clean the brass tube with some steel wool.

Stained glass is weather resistant so you can put these butterflies outside in your plant pots.

Wildflower Bouquet

This is a perfect way to brighten up any room and to use up scrap pieces of glass. After learning the basics to create flowers in this project, you're free to make your own – the possibilities are endless.

Glass

- Oceanside Yellow Opal Smooth Fusible 260-72S (Craspedia)
- Oceanside Light Amber Rough Rolled 110-4RR (Craspedia)
- Oceanside Grape Rough Rolled 543-2RR (Lavender)
- Oceanside Clear/White, Wispy Smooth Fusible 309S (Umbellifer)
- Oceanside Sea Green Rough Rolled Fusible 528-1RR (Leaves)
- Oceanside Champagne 591-1RR or 291-61SF (Pampas Grass)
- Wissmach 90-10 Orange Red (Poppies)

Tools & Materials

- 5.2mm ($1\frac{3}{64}$in) copper foil tape with black backing
- 1.8mm (13 gauge) galvanized steel wire
- 2.4mm (11 gauge) galvanized steel wire
- 2mm ($\frac{3}{32}$in) brass tube
- Glass paint or black porcelain marker
- Steel wool

Difficulty rating: Easy

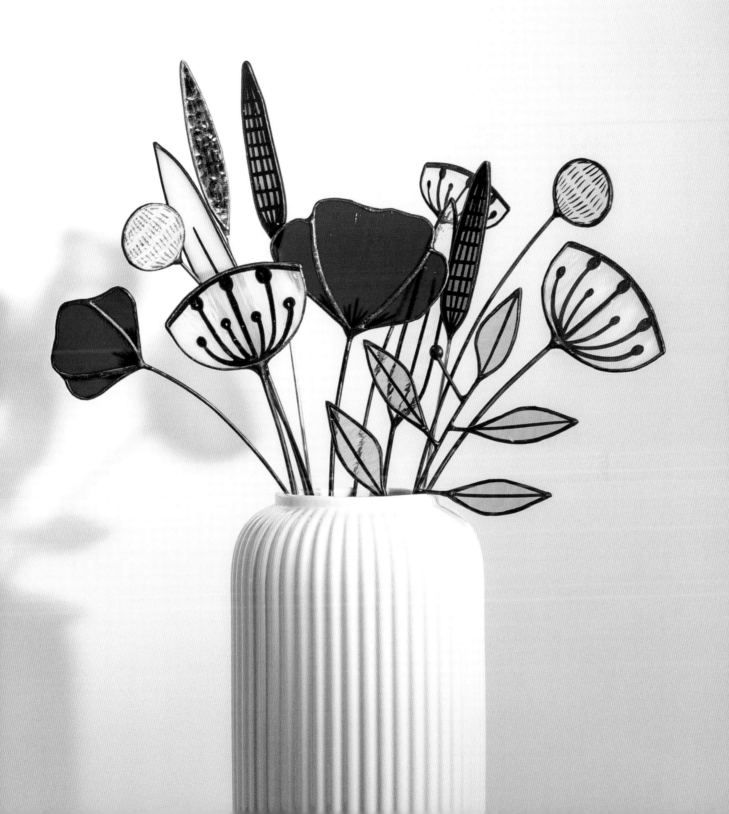

As most of the flowers are made in a similar way, I'm going into detail for only some of them. You can decide how long you want the stems to be, so I've not specified the amount of steel wire. The tallest stems in this project are 32cm (12½in), but you can easily trim the stems afterwards with some cutting pliers, or just make them shorter if you already know what vase you're going to show them off in.

CRASPEDIA

1. This is the easiest flower to make. After tracing the template, cutting and grinding the glass (see The Basics), paint the glass as shown in red on the template. Here, I'm using traditional paint but you can use a black porcelain marker (see How to Paint Glass). Then the pieces can be foiled (see How to Foil Glass).

2. To make the stem, take 32cm (12½in) of the thinner 1.8mm (13 gauge) galvanized steel wire and attach the flower to it. Make sure it's secure and bead the sides of the flower with a thick layer of solder (see How to Solder). After a final check of both sides of the flower, it's ready to be finished (see How to Finish a Project).

LAVENDER

3. The lavender is made the same way as the craspedia only this time you'll use a piece of 2mm (³⁄₃₂in) brass tube for the stem. Paint the glass as shown in red on the template, then foil it and solder it to the brass stem. The brass tube can be cut with regular cutting pliers. As the stem and the flower are only connected at this small point, make sure they are securely attached.

4. For the flowers to look neatly finished, bead the sides with a layer of solder that's as thick as possible. After finishing the flowers, you can clean the brass with some steel wool.

UMBELLIFER

5. The small umbellifer is made in the same way as the craspedia but the larger umbellifer will require some extra fortification on the back. Like the other flowers, you start with cutting and grinding the glass. Next, paint the pieces as shown in red on the template, then the pieces can be foiled.

6. To make the stem for the small umbellifer, use the thinner 1.8mm (13 gauge) galvanized steel wire but for the larger one you'll need the 2.4mm (11 gauge) wire. Solder the flowers to their stems.

7. To help strengthen the large umbellifier, solder a small piece of 1.8mm (13 gauge) galvanized steel wire on the back of the piece. Try to hide the metal wire behind the black paint line on the front.

8. Make sure that this fortification wire is directly attached to the stem and the top of the flower. Smooth out the solder on top of the flower. After a final check of both sides of the flowers, they're ready to be finished.

Depending on the paint you use, you will need to fire the pieces in the kiln or let them dry thoroughly.

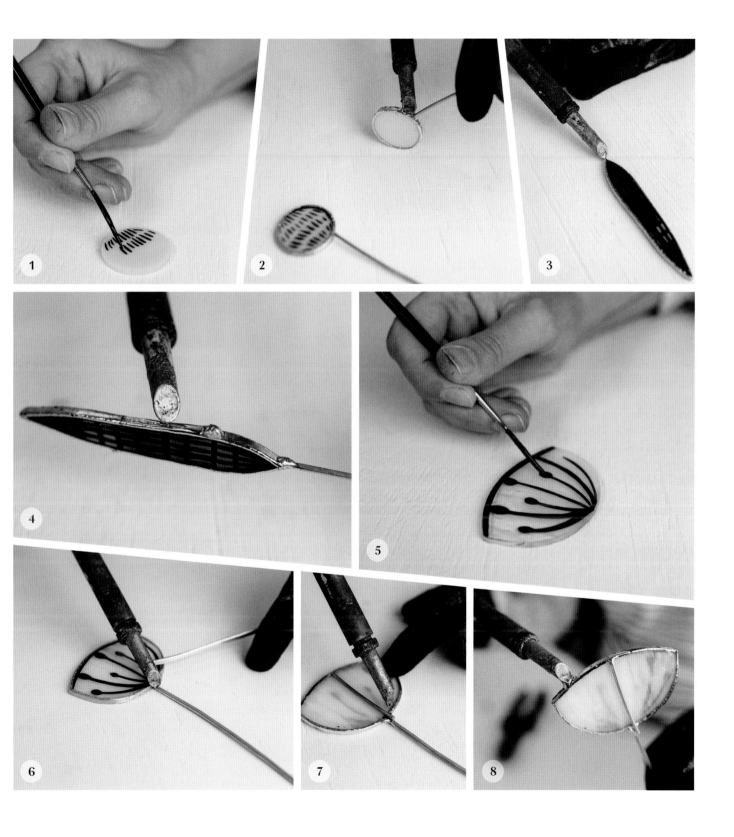

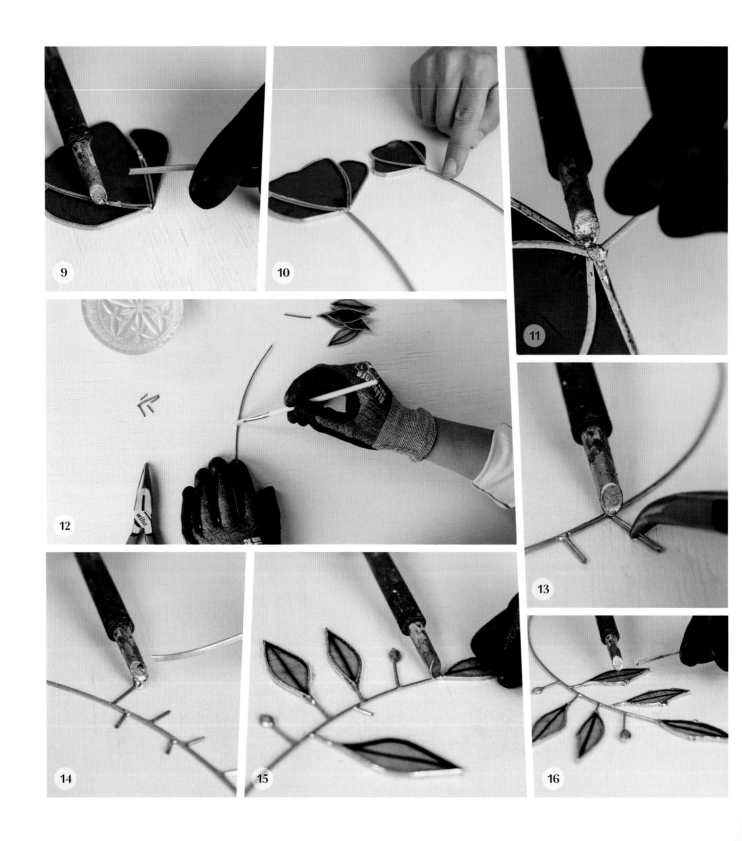

POPPIES

9. The poppies are made from three pieces of glass. This makes the flower much sturdier in comparison with the umbellifer. After cutting and grinding the glass, paint the pieces as shown in red on the template. Next, solder the three pieces together.

10. For the small poppy's stem, use the 1.8mm (13 gauge) galvanized steel wire but for the larger one you'll need the 2.4mm (11 gauge) wire.

11. Next, attach each flower to its stem. Make sure it's secure and bead the sides with a thick layer of solder. After a final check, they're ready to be finished.

You can also make pampas grass for the bouquet, using the same steps as for the craspedia and the small umbellifer, but use the 2.4mm (11 gauge) galvanized steel wire for the stems.

LEAVES

12. The leaves are the most complex design in the flower bouquet as it's made with a lot of small pieces. Prepare all the pieces of glass as you've done before and paint the glass as marked on the template. Cut one long stem and six small pieces of 1.8mm (13 gauge) galvanized steel wire according to the template.

13. Solder the small pieces of wire to the long piece, again as shown in the template. A tip to obtaining a smooth connection between the twigs and the stem is to only use a little bit of solder and plenty of flux.

14. Two of the little twigs don't have a leaf attached to them but are decorated with a ball of solder at the tip. You will need to put some extra flux on before you add a large drop of solder.

15. Keep checking the front and the back of the piece. Make sure the leaves are all secured properly because not only is it the most complex design in the bouquet, it's also the most fragile.

16. After going around each leaf with a thick layer of solder, the piece can be finished.

Suncatcher Mobile

The use of bevelled and striped glass adds an extra dimension to this Art Deco-inspired suncatcher. It will send colourful rays around wherever you choose to hang it.

Glass

- Oceanside Yellow Rough Rolled 161RR
- Oceanside Clear Quarter-Reed 100QR
- Wissmach Corella Classic 287
- Half-Circle Bevel (15cm/6in)

Tools & Materials

- 5.2mm (¹³⁄₆₄in) copper foil tape with black backing
- 30cm (12in) of 0.8mm (20 gauge) brass wire
- 70cm (27½in) of black metal chain
- 1 x 5mm (³⁄₁₆in) black split ring

Difficulty rating: Hard

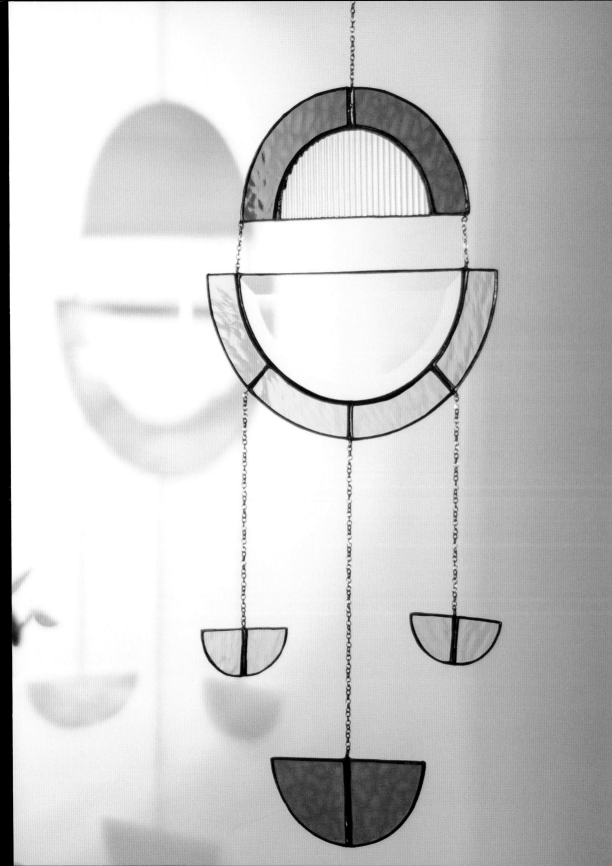

1. Trace the design and cut, grind and foil all the glass pieces (see The Basics). You'll then need to make 11 small similar-sized pegs for this project (see Materials: Pegs), using the brass wire.

2. Next assemble the green top piece. This has three pegs – two of them are on the outside bottom edge. Attach these two pegs with a drop of solder (as shown on the template by red arrows), making sure they are level so the chain hangs straight. The third peg is positioned at the top between the two pieces of green glass. Secure it with a drop of solder as well.

3. Continue to construct each part of the mobile in the same way, adding the pegs as you go. Place the glass pieces in the correct position and tack solder (see How to Solder) everything into place.

Never add a peg to the middle of a piece without a solder join, otherwise the copper foil tape will be torn off in time by the weight of the piece.

4. Twist all of the pegs 90° by reheating the solder that holds them in place, and then bead the inside lines.

5. The next step is to bead the edges of all the pieces. Try to make the lines as smooth as possible.

6. After checking all the pieces thoroughly, they are ready to be finished (see How to Finish a Project).

7. As a final step, we need to add the chains. It's very important to measure the chain lengths exactly so the mobile hangs straight: the top chain is 10cm (4in) with a 5mm (³⁄₁₆in) split ring at the top to hang the mobile, the middle chains are 2.5cm (1in), and the bottom chains are two 12cm (4¾in) and one 18cm (7⅛in).

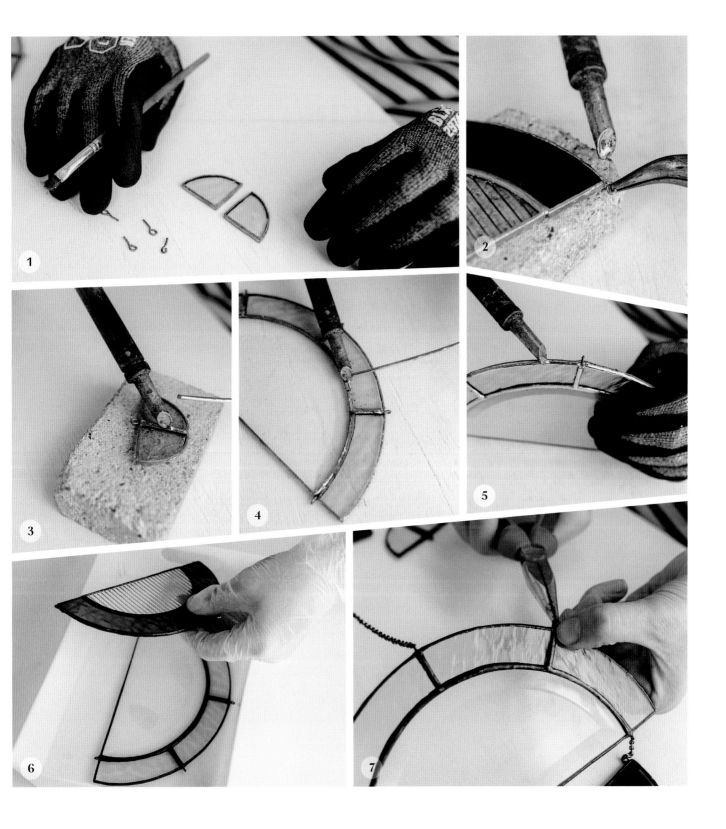

Heart Suncatcher

Making this lovely heart piece will show you how to frame a piece with brass U-channel. This technique not only makes your work sturdier, but it will also give it a professional finish.

Glass

- Oceanside Clear Granite 100G
- Oceanside Medium Amber Rough Rolled 110-8RR
- Wissmach Corella Classic 134
- Wissmach Corella Classic 418

Tools & Materials

- 5.2mm (13⁄64in) copper foil tape with black backing
- 2.5cm (1in) of 0.8mm (20 gauge) brass wire
- 70cm (27½in) of 4mm (5⁄32in) brass U-channel
- Black marker pen
- Tin snips or Lil Notcher
- 50cm (19¾in) of black metal chain
- 1 x 5mm (3⁄16in) black split ring

Difficulty rating: Medium

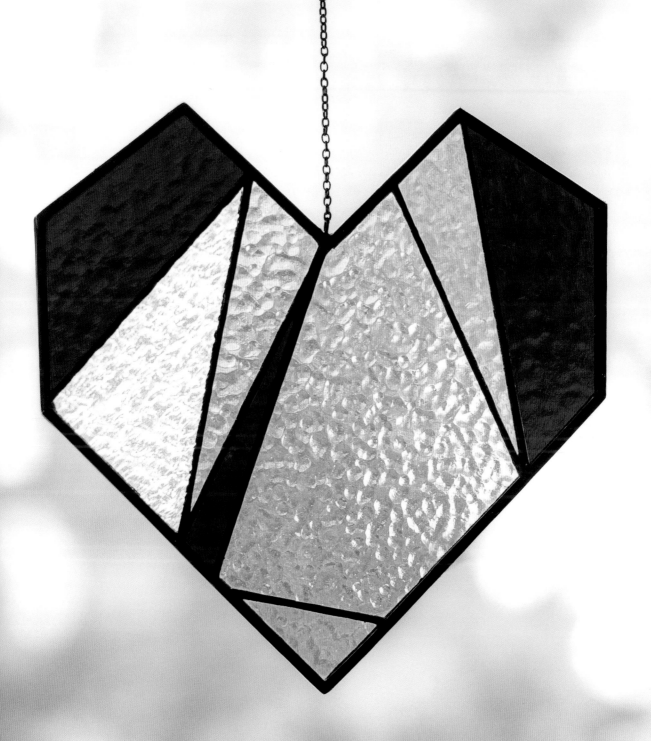

1. Trace the design and cut, grind and foil all the pieces (see The Basics). Assemble the glass as per the template and tack solder to secure them (see How to Solder). Be sure to leave a small gap for the peg, as shown by the red arrow on the template. Tin solder the piece on both sides but not the edges.

2. Bend the 0.8mm (20 gauge) brass wire into a peg (see Materials: Pegs) and tin it.

3. Secure the peg with some solder. Tin around the outside edge of the heart, but don't use too much solder so the U-channel will still fit easily.

4. To attach the U-channel, start at the centre of the heart where the peg is placed.

5. Use a marker to identify where the U-channel will need to bend.

6. You can use tin snips or a Lil Notcher to bend the U-channel. Always cut out a little triangle so the brass will bend properly.

7. If you use the Lil Notcher, you can place the mark in the centre of it and push out the triangle.

8. Bend the brass channel around the heart. Adjust your cuts if necessary.

You can always use smaller pieces of U-channel cut to the correct length – you don't have to use one continuous piece.

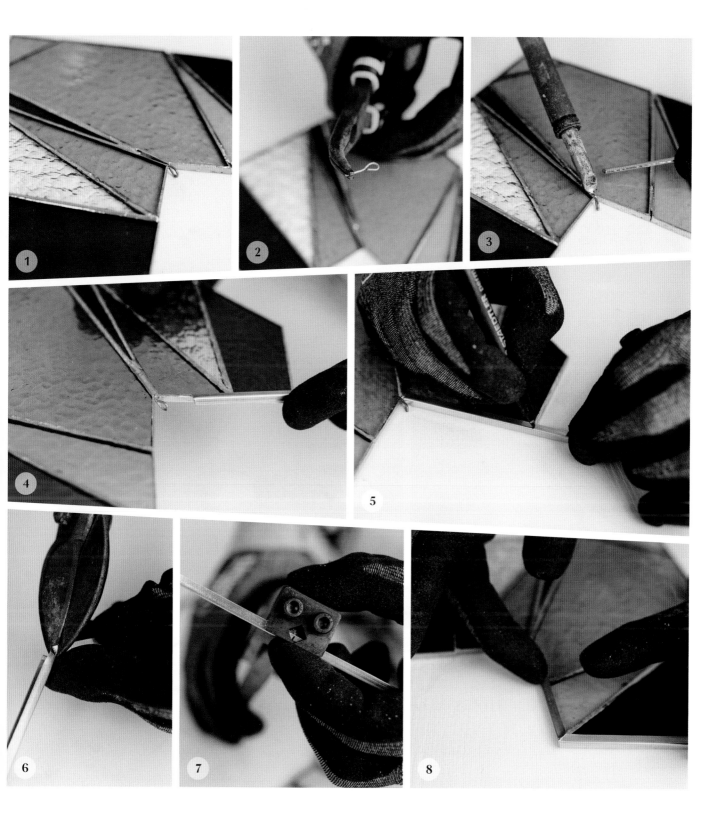

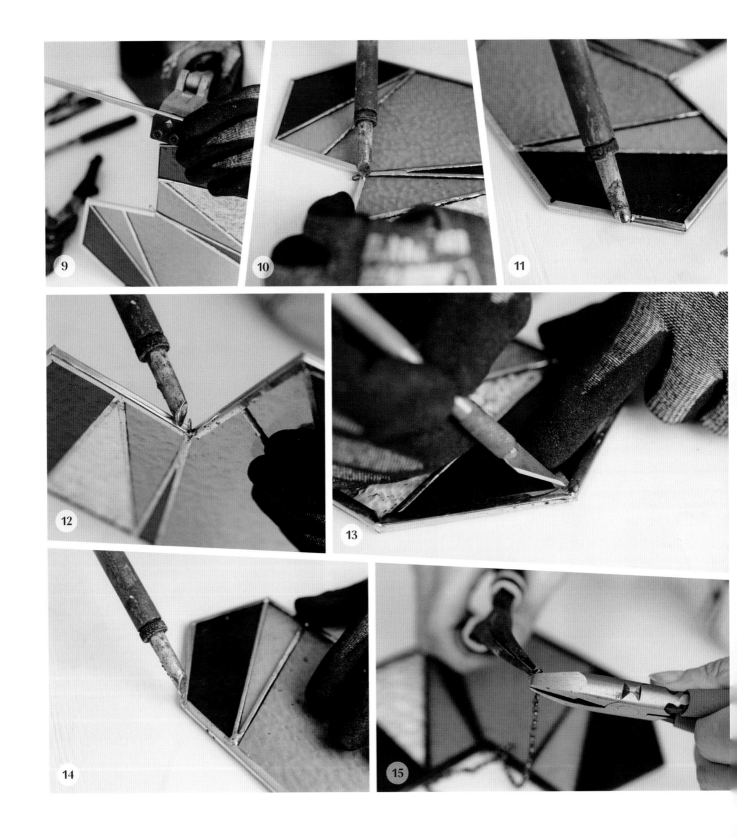

9. Work your way around the whole piece to completely frame the heart.

10. Solder the U-channel together where it meets in the middle of the heart.

11. The next step is to tin all the brass U-channel.

12. Be careful not to close the eye of the peg with solder. If this happens, heat up the solder again and shake it off.

13. If there are any holes in the brass U-channel, you can fill them with small pieces of copper foil.

14. Cut the foil to shape and secure it with a drop of solder.

15. After finishing the piece (see How to Finish a Project), add the black chain to the peg and a split ring at the top to hang the suncatcher.

I use brass U-channel and tin it instead of zinc because the latter doesn't turn black as nicely after putting the patina on.

Cactus Plants

I made my first cactus after a visit to Arizona, but as they come in so many shapes, sizes and colours I keep creating new ones. This project will show you two different ways to add extra detail to these cute plants.

Glass

Cactus 1

- Wissmach Mystic 343

Cactus 2

- Oceanside Yellow Rough Rolled 161RR
- Wissmach Mystic 309

Tools & Materials

Cactus 1

- 5.7mm (7/32in) copper foil tape with black backing
- 150cm (59in) of 0.8mm (20 gauge) brass wire

Cactus 2

- 5.7mm (7/32in) copper foil tape with black backing
- 15cm (6in) of 1.8mm (13 gauge) galvanized steel wire
- Glass paint or black porcelain marker

Difficulty rating: Easy

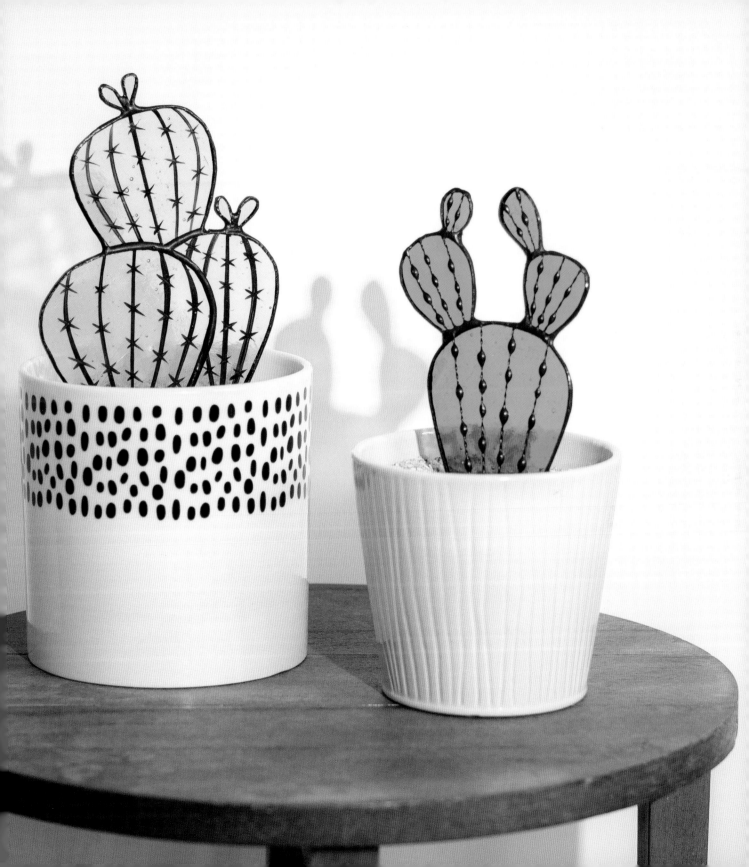

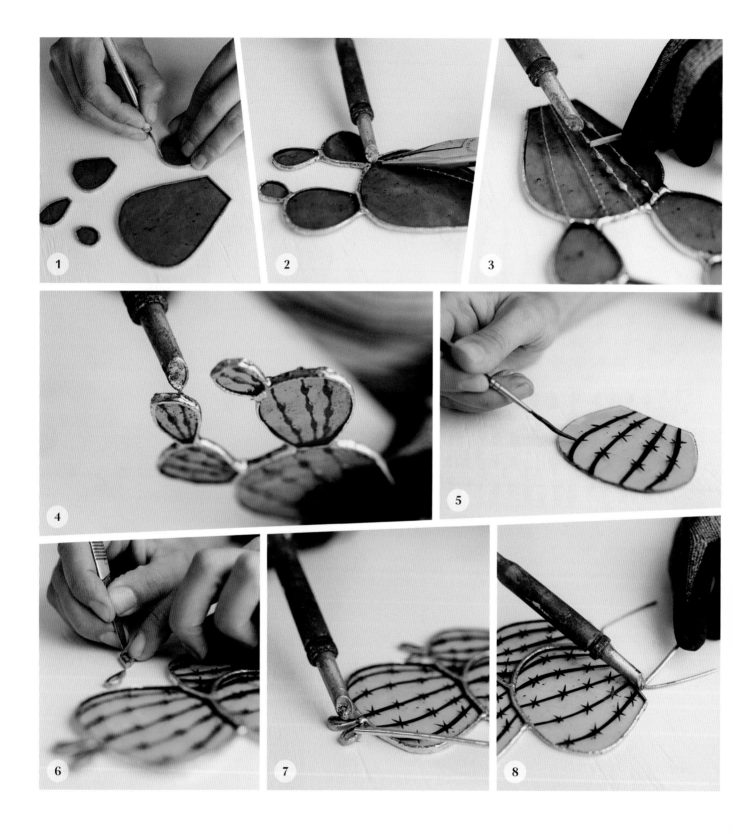

CACTUS 1 – WIRE DETAILS

1. Start by tracing the template (see How to Transfer Templates). Cut the five pieces of green glass. Grind, foil and solder them together as shown in the template (see The Basics).

2. Next, add some twisted wire details (see Materials: Twisted Wire). Cut the wire to size and solder into place as shown in red on the template.

3. Create some more detail by adding drops of solder along the wire. You can add as many as you like, using the template as a guide.

4. After applying the twisted wire and solder drops, check the piece thoroughly and bead the edges to help secure the twisted wire at both ends. Now the piece is ready to be finished (see How to Finish a Project).

Use a piece of oasis and some small stones to plant these cacti in their own pots

CACTUS 2 – PAINTED DETAILS

5. Start by tracing the template. After cutting and grinding the green glass, paint the pieces as shown in red on the template (see How to Paint Glass). Here, I'm using traditional paint but you can use a black porcelain marker. Depending on the paint you use, let the pieces dry or fire them in a kiln. After this, all the green pieces can be foiled and soldered.

6. The pieces for the yellow flowers are very tiny so you might want to trim away some of the copper foil with a craft knife to show more of the yellow glass. See How to Foil Glass for tips on foiling small pieces.

7. Next, attach the two tiny yellow flowers and solder them.

8. To enable the cactus to stand upright, add an attachment made from 15cm (6in) of 1.8mm (13 gauge) galvanized steel wire. Bend it into a U-shape with bent nose pliers before soldering it to the bottom of the cactus. After checking the piece thoroughly, it is ready to be finished (see How to Finish a Project).

Art Deco Planter

This planter makes any plant look good. The challenge with this project is in the construction. A little tip to start with: the more precise you work, the easier it will be to assemble it.

Glass

- Oceanside Ivory Opal 210-71S-F
- 5 small pieces of opalescent coloured glass:
 - Oceanside Pastel Green Opal 222-72S
 - Oceanside Peacock Green Opal 223-74S
 - Oceanside Yellow Opal 260-72S
 - Oceanside Dark Blue Opal 230-76S
 - Oceanside Red Opal 250-72S

Tools & Materials

- 5.2mm (¹³⁄₆₄in) copper foil tape with black backing
- Self-adhesive rubber feet

Difficulty rating: Medium

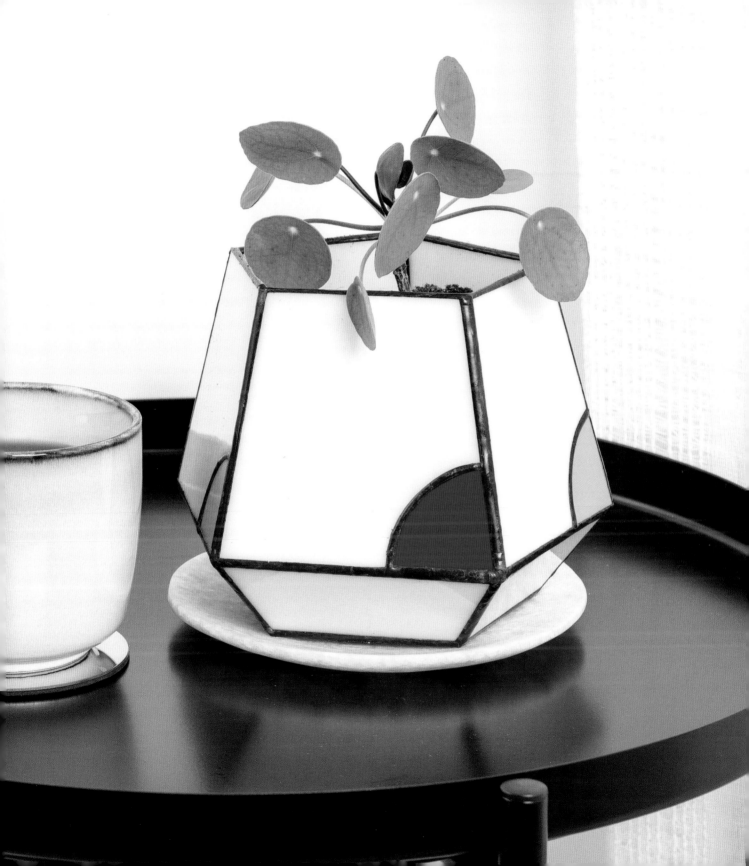

1. Trace the template using carbon paper onto the opaque glass (see How to Transfer Templates). After cutting, grinding and foiling the glass, solder together (see The Basics) the two pieces that make up the five upper sides – pieces 1 and 2 on the template. Ensure that all pieces fit well together.

2. After applying flux, you can start to attach the smaller sides (piece 3 on the template) to the bottom piece (piece 4). It's important to only attach the pieces with a small drop of solder (tack solder) so that you can still adjust the angle and the position. Constructing the planter from the bottom up means that the finished product will be level.

3. Continue attaching the lower side pieces. As you do this, you may notice that they don't fit neatly together. To rectify this, reheat the solder and reposition until all five sides fit perfectly.

4. After finishing the bottom part of the planter, completely solder the inside. This needs to be done now, as once the upper sides are on, this section will be harder to reach.

You'll see pencil marks on some of the pieces of glass in the step images. The glass had some air bubbles on the surface, so I chose which were the best sides to go on the outside of the planter. It's useful to do this before soldering any project.

5. Now connect the upper sides. Use the same tack soldering technique to attach the pieces with small drops of solder at first to make sure you're able to adjust their position if necessary.

6. After assembling the pieces, solder the inside of the planter. Solder the inside first so that the excess solder flows to the outside.

7. As the solder lines on the inside of the planter are very thin, the space between the pieces on the outside is larger. Simply fill these gaps by adding more solder as a first step, and make sure you cover all the foil with solder. Once this is done, move on to beading.

8. Bead the top using the same technique as you did to solder the sides. After checking the piece thoroughly, it's ready to be finished (How to Finish a Project). You can attach some self-adhesive rubber feet to the bottom to finish off the piece.

If you use an inner pot, only the lower part of the planter needs to be waterproof. You can check this easily by pouring some water into it before finishing the piece.

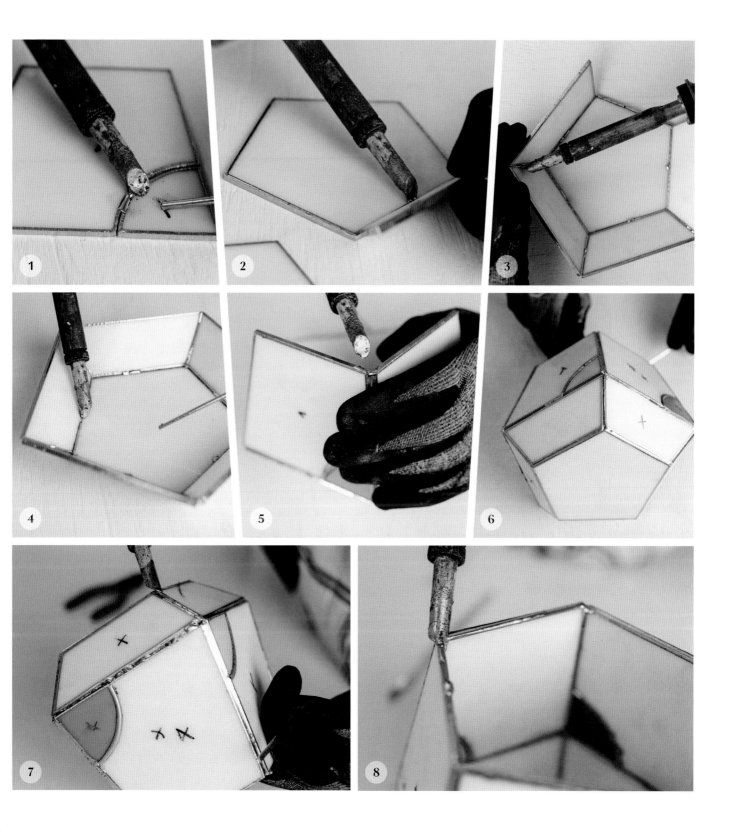

Square Panel

The simple lines and classic colours of this little beauty makes it an elegant addition to your home. It's also the perfect project to show you how to create a sturdy suspension system for larger projects.

Glass

- Oceanside Steel Blue Rough Rolled 538-4RR
- Oceanside Orange Rough Rolled 171RR
- Oceanside Clear/White Smooth 308S
- Wissmach Mystic 0002

Tools & Materials

- 5.2mm (¹³⁄₆₄in) copper foil tape with black backing
- 15cm (6in) of 1mm (18 gauge) galvanized steel wire
- 90cm (35½in) of 4mm (⁵⁄₃₂in) brass tube
- Small metal saw
- Wooden board with L-square
- 80cm (31½in) of black metal chain

Difficulty rating: Hard

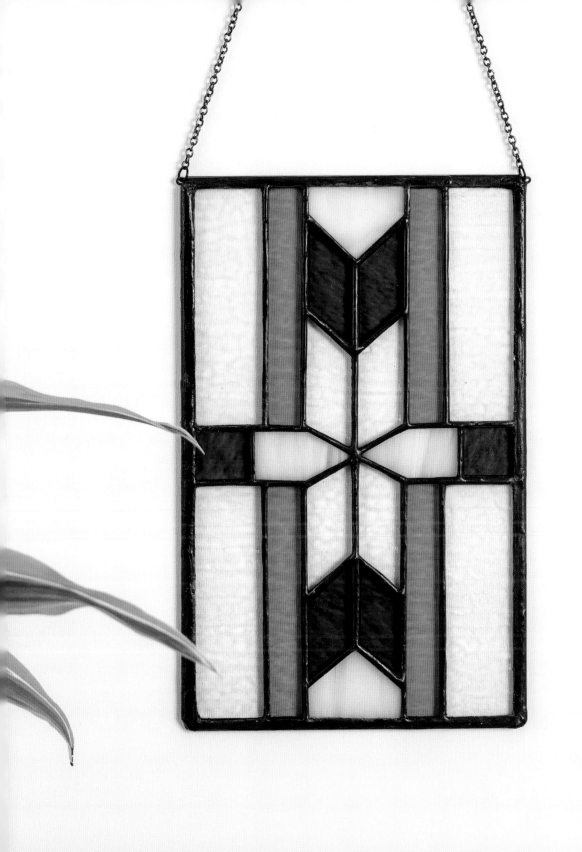

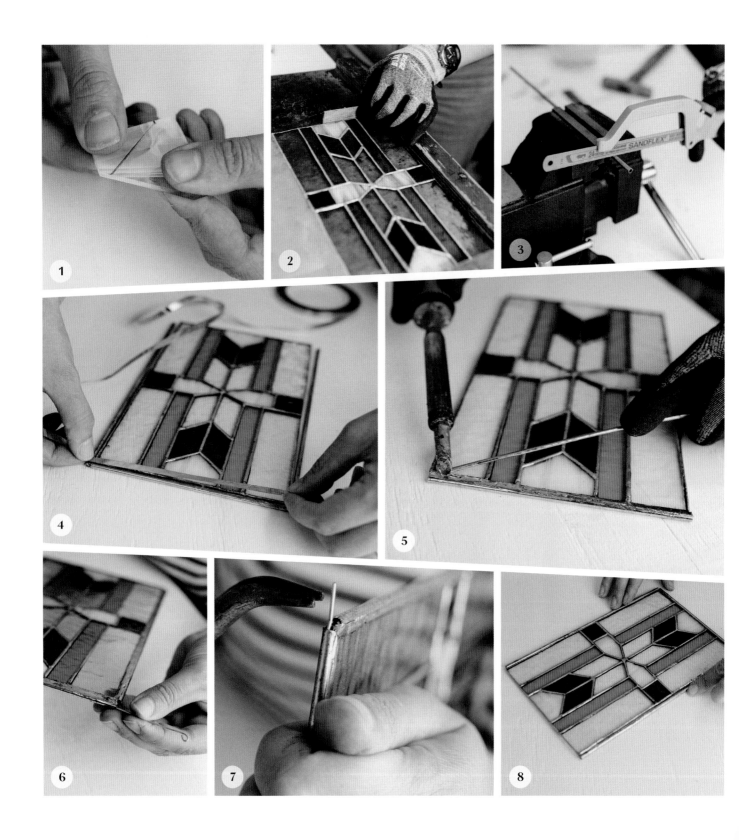

1. Trace and mirror the template along the dotted red line to create the complete template for this project (see How to Transfer Templates). Cut, grind and foil all the pieces according to the template (see The Basics). In this design, it's very important for the glass to have nice sharp points. You can achieve this by leaving a little extra glass at the points when you cut the glass – you'll get a cleaner break and you can sharpen them if necessary with the grinder. It's always best to use an L-square when you cut any size of glass, but again very important in this project with all the straight lines.

2. As we are making a rectangular design, assemble all the pieces on the wooden board. Make sure that all edges are straight by locking the pieces in place with some small wooden blocks and the L-square. Tin solder the whole panel. Make sure the copper foil on the border of the panel is nice and straight as it won't be covered up with a brass or lead U-profile in this project as it is in other projects.

3. Cut four pieces of brass tube with a small metal saw to frame all four sides. The top piece must be 5mm (³⁄₁₆in) narrower than the panel. Tin all four pieces. Be sure to keep the inside of the shorter piece free from solder.

4. Clean the panel and the four pieces of brass. Cut the copper foil in half lengthways to make some narrow strips. As it's difficult to avoid solder flowing from one side of the panel to another, attach the brass tubes with these narrow foil strips on one side of the panel only. This is to prevent the solder flowing through but the brass is still firmly attached to the panel.

5. After tin soldering all four pieces of brass on both sides using the same technique, bead the solder lines on both sides of the panel.

6. Next, take the 15cm (6in) of galvanized steel wire and bend it with bent nose pliers into a peg at one end. Insert it into the top brass tube. Attach the peg end with some solder to prevent it from turning.

7. Make another peg at the other end of the galvanized steel wire and solder it.

8. After checking the piece thoroughly, it is ready to be finished (see How to Finish a Project). Attach the black chain to the pegs as the final touch.

You might not be happy with the longer solder lines the first time you do them. Just take your time, let the piece cool down and try again.

Corner Panel

A beautiful way to add detail to a dull corner. I'll show you a clever way to attach a small panel to a wooden doorway or window frame. Just make sure the corner you want to put the panel in is square too!

Glass

- Oceanside Cherry Red Rough Rolled Fusible 151RR
- Oceanside Sea Green Rough Rolled Fusible 528-1RR
- Oceanside Pink Champagne Rough Rolled Fusible 591-1RR
- Wissmach English Muffle 01 - Clear

Tools & Materials

- 5.2mm ($1\frac{3}{64}$in) copper foil tape with black backing
- 110cm ($43\frac{1}{2}$in) of 4mm ($\frac{5}{32}$in) brass U-channel
- Wooden board with L-square
- Black marker pen
- Tin snips
- Rubber hammer
- Metal hammer
- Drill with a 2.5mm ($\frac{3}{32}$in) metal bit

Difficulty rating: Hard

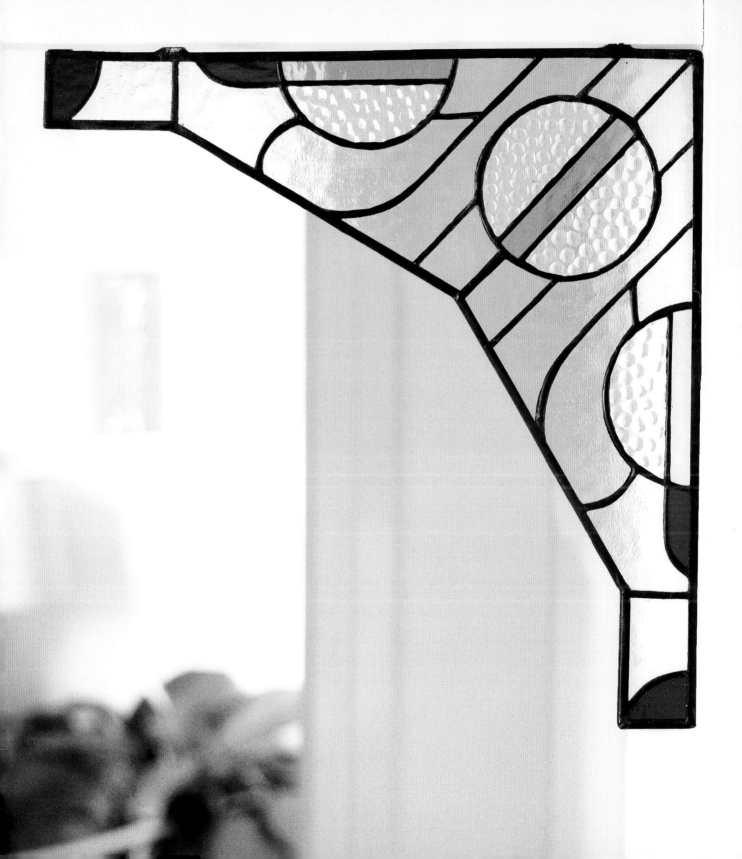

1. Trace the two template pieces to make one complete template. Next, cut, grind and foil all the glass pieces (see The Basics). If you want to make a perfectly square panel, you will need a wooden board with an L-square. Assemble all the pieces as shown in the template. I use small blocks and some nails to secure the pieces in place.

2. The panel will be framed with 4mm (⁵⁄₃₂in) brass U-channel. After making sure all the pieces fit well together, tin solder the whole panel (see How to Solder).

3. Take the panel off the wooden board and start to frame it with the brass U-channel.

4. I always start with the longest side that needs to be framed. You can try to frame the panel with one complete piece of brass, but I suggest you use smaller pieces as it's easier to handle. Use a marker to identify where the U-channel will need to bend.

5. Always cut out small triangles to make the brass bend properly. Some have blunt angles so you have to use the tin snips for this, not the Lil Notcher.

6. At this stage, I have already soldered the top U-channel onto the panel. This will help to keep the brass in place while framing it.

7. Use your rubber hammer to flatten the brass before you start to solder.

8. Tin solder the brass U-channel on all three sides.

If you are struggling to fit the brass U-channel onto the glass then try opening up the channel with a fid.

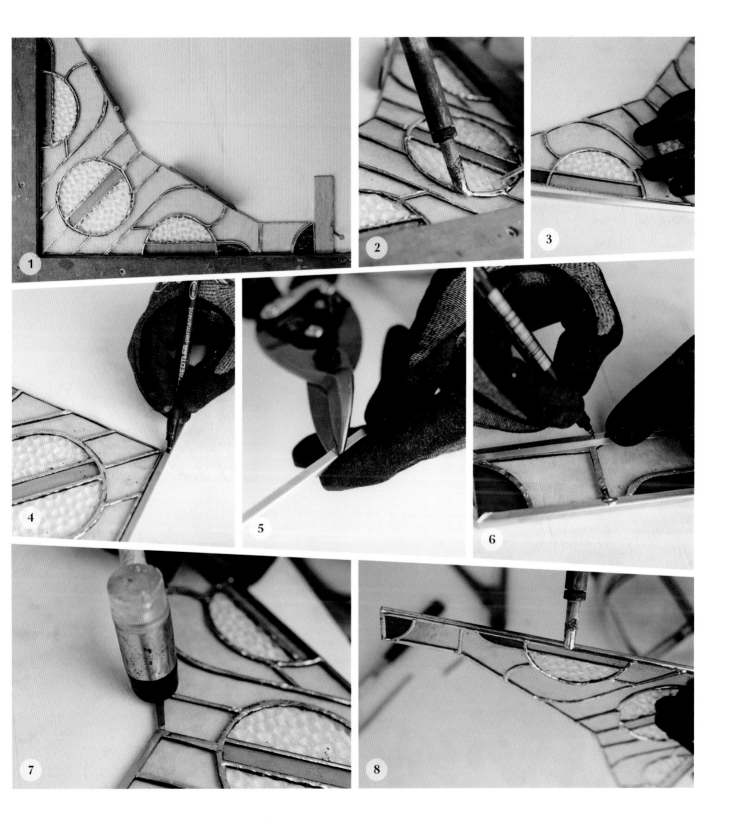

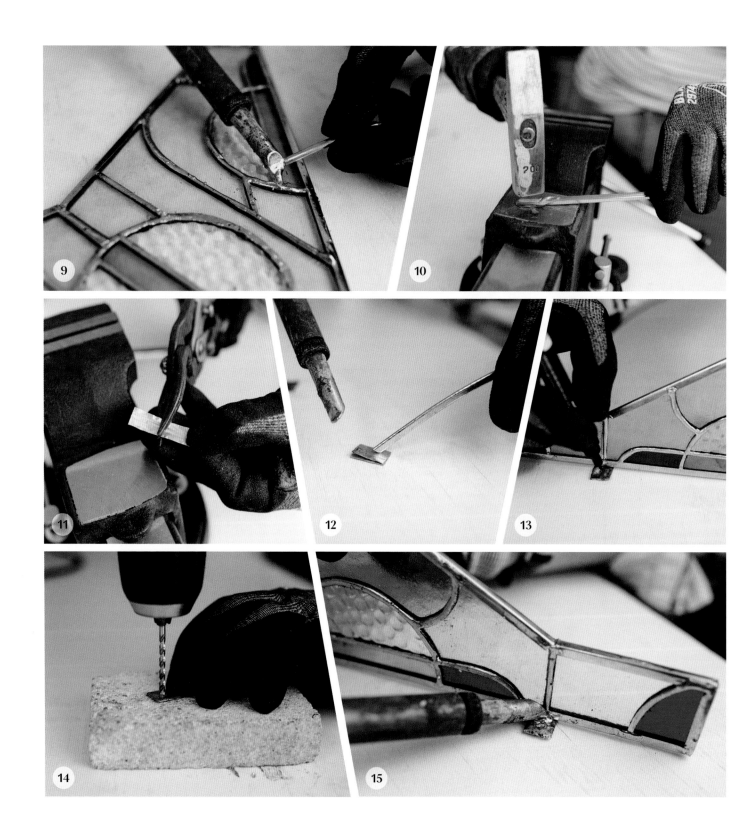

9. Now bead the inside solder lines. After finishing the solder neatly, start on the custom-made suspension system.

10. Take 10cm (4in) of leftover brass channel and flatten it on a hard surface, such as a vice, with a metal hammer.

11. Cut this into four pieces of 2.5cm (1in) with the tin snips.

12. Solder two pieces together, one on top of the other, to make two custom-made metal pieces.

13. Use a marker to identify where to place a hole on both custom pieces.

14. Drill a 2.5mm (3⁄32in) hole in each of the metal pieces.

15. Attach the two metal pieces with solder, as shown by red arrows on the template. Make sure the panel is still level after attaching them. After checking the piece thoroughly, it's ready to be finished (see How to Finish a Project).

Use some wall plugs and screws to mount the panel in a corner.

Small Panel with Stand

This project shows you an easy way to make small items stand without the need for other materials. We'll also look at how to achieve beautiful details without paint.

Glass

- Oceanside Clear/White Smooth 308S
- Wissmach Cube Clear

Tools & Materials

- 5.2mm (13⁄64in) copper foil tape with black backing
- 65cm (25½in) of 1mm (18 gauge) galvanized steel wire
- 90cm (35½in) of 4mm (5⁄32in) brass U-channel
- Wooden board with L-square
- Tin snips or Lil Notcher
- Self-adhesive rubber feet

Difficulty rating: Medium

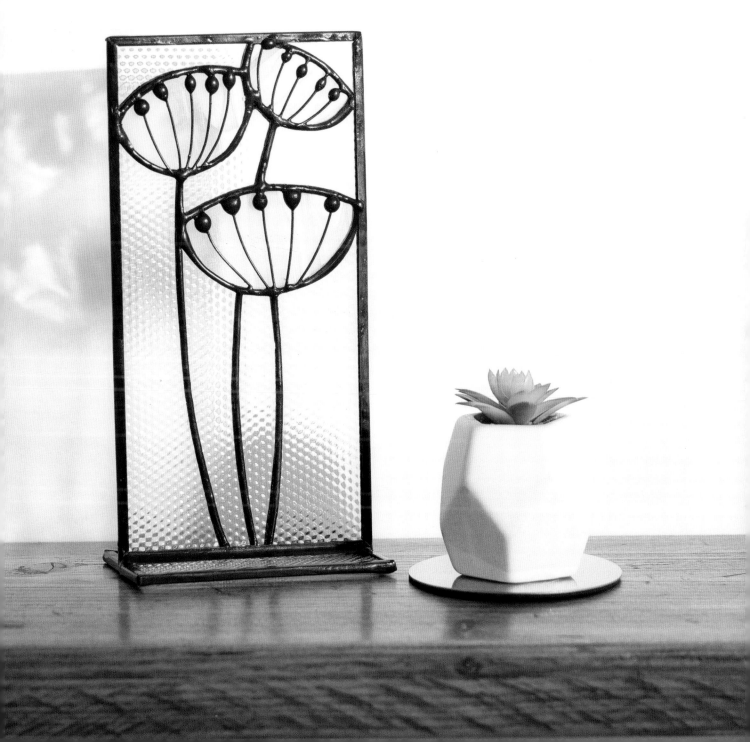

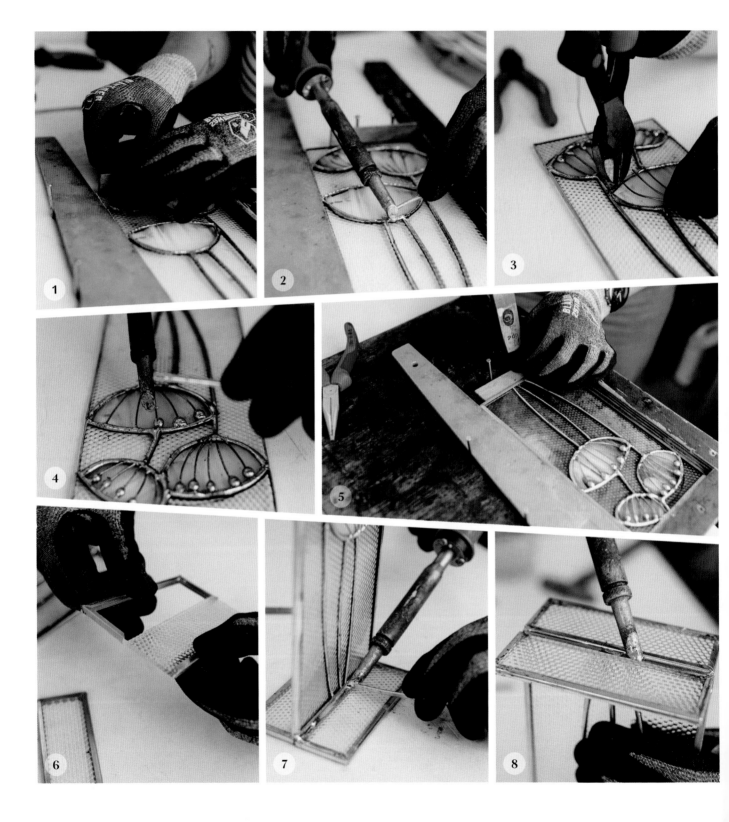

1. Start by tracing the template (see How to Transfer Templates). Next cut, grind and foil all pieces according to the template (see The Basics). Assemble the glass on the wooden board and fix it with the L-square to ensure the little panel is kept straight. Keep the two small rectangle pieces separate for now.

2. Tin solder one side of the panel (see How to Solder), then release it from the board. Solder the other side of the panel. Remember to only use a thin layer of solder on the edges – if it's too thick the brass U-channel won't fit over it.

3. For the details, use the 1mm (18 gauge) galvanized steel wire. These are shown as red lines on the template. Attach the wire to both sides of the flower head.

4. Apply large drops of solder as an extra detail, as shown by the red circles on the template.

5. Frame the panel with the brass U-channel, using the same method as in the Corner Panel project. To make sure the angles are straight, put the panel back on the wooden board and secure it again. Solder the brass border and finish the solder on the whole piece.

6. Next, frame the two small rectangular pieces of glass with brass U-channel and cover the brass with solder.

7. Put the central panel with the umbellifer flowers on top of the two rectangular pieces. Make sure it stands straight and solder it together.

8. Finish soldering the bottom and the sides. After checking the piece thoroughly, it's ready to be finished (See How to Finish a Project). You can put some self-adhesive rubber feet on the bottom to prevent it from marking the surface it stands on.

The shiny gold inside of the brass U-channel will turn dark brown when you apply patina so it won't stand out when the piece is finished.

Rainbow Panel

Somewhere over the rainbow... there's a world made of coloured glass. The arch shapes of the pieces are a little tricky to cut but you can correct a lot if you take your time when grinding.

Glass

- Oceanside Cherry Red Rough Rolled Fusible 151RR
- Oceanside Orange Rough Rolled 171RR
- Oceanside Yellow Rough Rolled 161RR
- Oceanside Teal Green Rough Rolled 523-2RR
- Oceanside Sea Green Rough Rolled 528-1RR
- Oceanside Steel Blue Rough Rolled 538-4RR
- Oceanside Light Purple Rough Rolled 142RR
- Oceanside Grape Rough Rolled 543-2RR
- Oceanside Blue Rough Rolled Fusible 136RR

Tools & Materials

- 5.2mm ($1^{3}/_{64}$in) copper foil tape with black backing
- 5cm (2in) of 0.8mm (20 gauge) brass wire
- 60cm (24in) of 2mm ($^{3}/_{32}$in) round U-lead came
- 80cm (31½in) of black metal chain
- 2 x 5mm ($^{3}/_{16}$in) black split rings

Difficulty rating: Medium

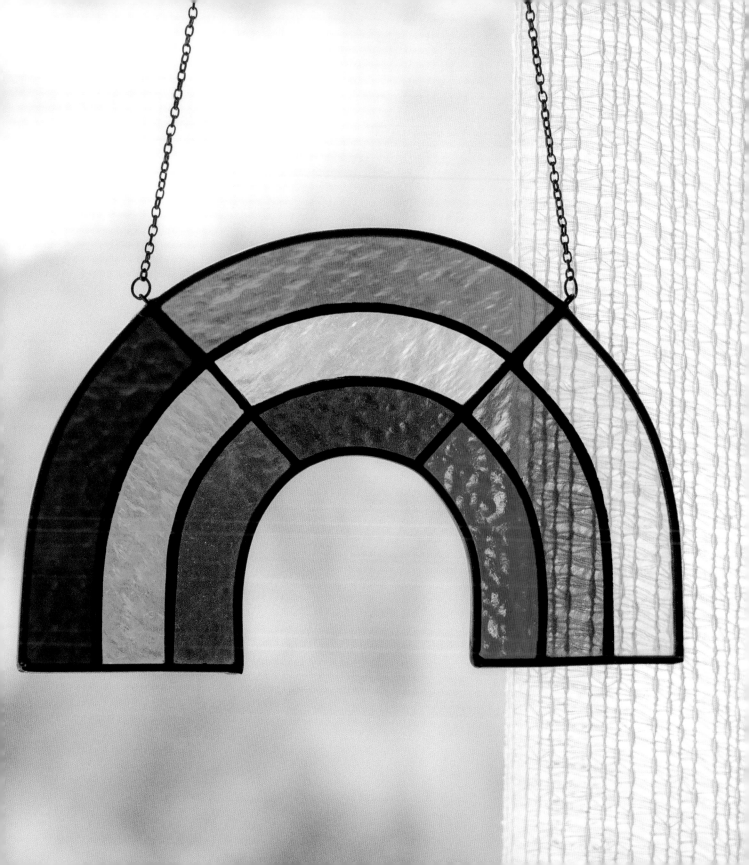

1. First trace the template, then cut and grind all the pieces (see The Basics). Next, foil the pieces (see How to Foil Glass) but as you are working with the narrow U-lead, you don't foil the outside edges of the pieces.

2. Bend two pegs around 2.5cm (1in) long from the 0.8mm (20 gauge) brass wire (see Materials: Pegs) and solder them in place, as shown in red on the template. Tin solder both sides of the rainbow (see How to Solder).

3. Lift the piece a bit and heat the solder where the pegs are attached. When heated enough, twist the pegs 90°. This makes it easier to get the U-lead to fit perfectly.

4. After stretching and opening the U-lead (see Materials: Lead), wrap the lead came around each rainbow section, shown as bold lines on the template, and cut with cutting pliers. You should now have six separate pieces of lead came.

5. Solder the ends of each piece of lead to the rainbow panel to make a frame. Be aware that tin solder has a lower melting point than lead but sometimes when the soldering iron gets too hot the lead can start to melt. It's very difficult to cover this up so it's better to replace the melted lead pieces completely.

6. Be careful not to fill the pegs with solder.

7. Now solder the U-lead to the copper foil and put a final layer of solder on both sides of the rainbow.

8. After checking the piece thoroughly, it's ready to be finished (see How to finish a Project). Then attach the chain to the pegs.

This design looks great if you don't use the black patina and leave the solder lines silver.

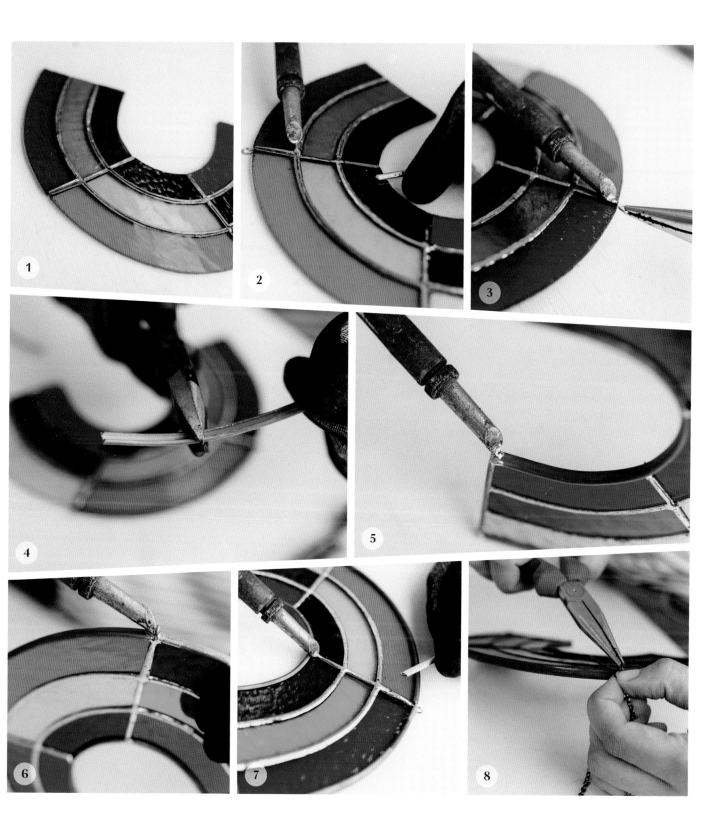

Round Panel

This pretty Art Deco-inspired panel in green and yellow comes with some challenging shapes. Working on this project will give you practice at cutting curves and creating the perfect circle.

Glass

- Oceanside Medium Amber Rough Rolled 110-8RR
- Oceanside Hunters Green Rough Rolled 523-8RR
- Wissmach Mystic 343
- Wissmach Mystic 309

Tools & Materials

- 5.2mm ($\frac{13}{64}$in) copper foil tape with black backing
- 2.5cm (1in) of 0.8mm (20 gauge) brass wire
- 70cm (27½in) of 2mm ($\frac{3}{32}$in) round U-lead came
- Fid
- 50cm (19¾in) of black metal chain
- 1 x 5mm ($\frac{3}{16}$in) black split ring

Difficulty rating: Hard

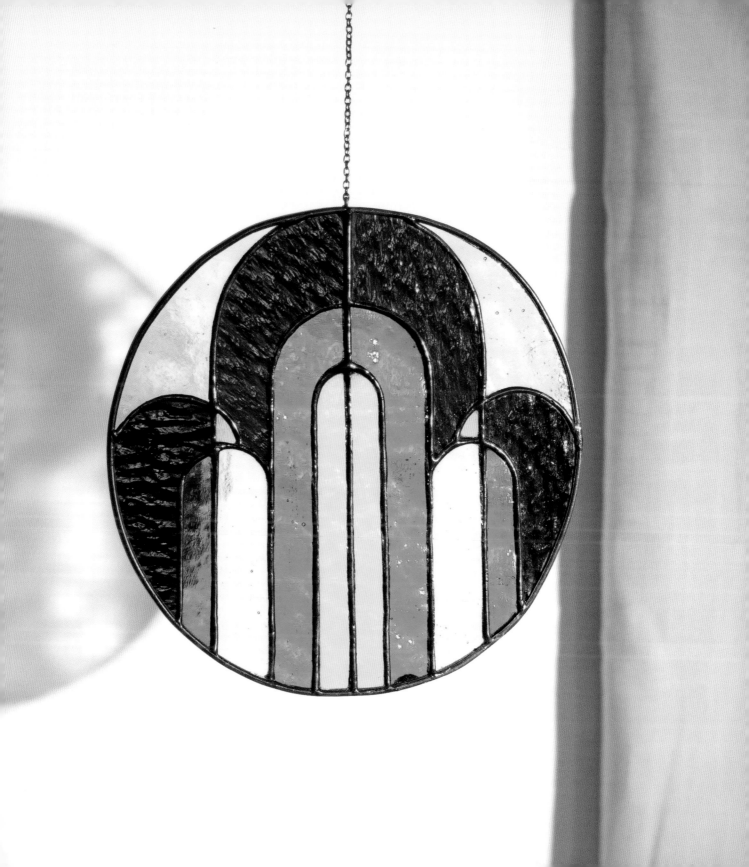

1. Every glass brand has different properties and some of the sheet glass used in this project has a very wavy surface. When working with this kind of textured glass, take a little more time to make sure all lines are straight after foiling, trimming them with a craft knife if necessary.

2. After mirroring down the straight edge of the template and tracing to make the complete circle, you can cut, grind and foil all the pieces and assemble according to the design (see The Basics). As we will be working with 2mm (³⁄₃₂in) round U-lead, the outside edges won't be foiled. Foiling adds another layer of thickness to the glass but as the channel of the lead came is only 4mm (⁵⁄₃₂in) we don't want to add anything more otherwise the lead won't fit.

3. As this is a round design, you have no straight edge to use as a starting point for the assembly, so just try to follow the template as closely as possible. Try to keep the shape of the circle and keep the pieces in place with some nails or drawing pins.

4. Tin solder the whole panel on the front and back (see How to Solder). Don't take the solder all the way to the edge of the circle but leave at least 3mm (¹⁄₈in) of the copper foil unsoldered. This is to make sure the U-lead will still fit around the panel.

5. Make a peg (see Materials: Pegs) with the brass wire and attach it with some solder as marked with a red arrow on the template. When working with U-lead, always twist the peg 90° so there's a nice fit with the lead. Reheat the solder to allow the peg to twist if you need to.

6. As the glass is 3mm (¹⁄₈in) thick and some of it has a wavy surface, it's important to open the lead with a fid so that it's wide enough to fit the glass.

7. Start at the peg and place the lead tightly around the panel. Attach the beginning with some solder to hold it in place then cut the lead to the required length, adding another drop of solder at the other end. Finish the solder work by soldering the copper foil you left bare in step 4, then bead the whole panel.

8. Make sure you've soldered all the sides where the peg is attached. After checking the piece thoroughly, it's ready to be finished (see How to Finish a Project). As the final step, attach the black chain to the peg and a split ring at the top to hang the panel.

Don't hesitate to recut a piece of glass when necessary – we all have to at some point. It will be worth it.

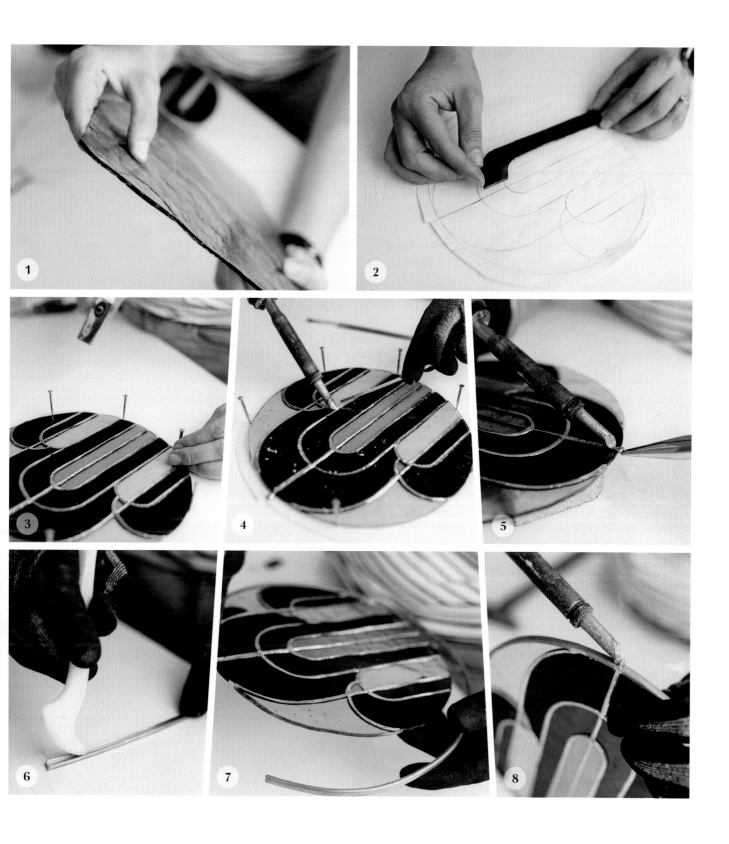

Triangular Design with Brass

The golden colour of brass always gives a piece a little extra something. I've created this simple tree design as an example but lots of combinations are possible with only a couple of pieces of glass and some brass profile.

Glass

- Oceanside Teal Green Rough Rolled Fusible 523-2RR-F
- Triangle Bevel (7.6cm/3in on all sides)

Tools & Materials

- 38cm (15in) of 4mm ($\frac{5}{32}$in) brass U-channel
- 8cm (3⅛in) of 4mm ($\frac{5}{32}$in) brass H-profile
- Gold Marabu Yono marker pen
- Black marker pen
- Small metal saw
- Tin snips or Lil Notcher
- Rubber hammer
- Steel wool
- 50cm (19¾in) of gold-coloured chain
- 2 x 10mm (⅜in) gold-coloured split rings

Difficulty rating: Easy

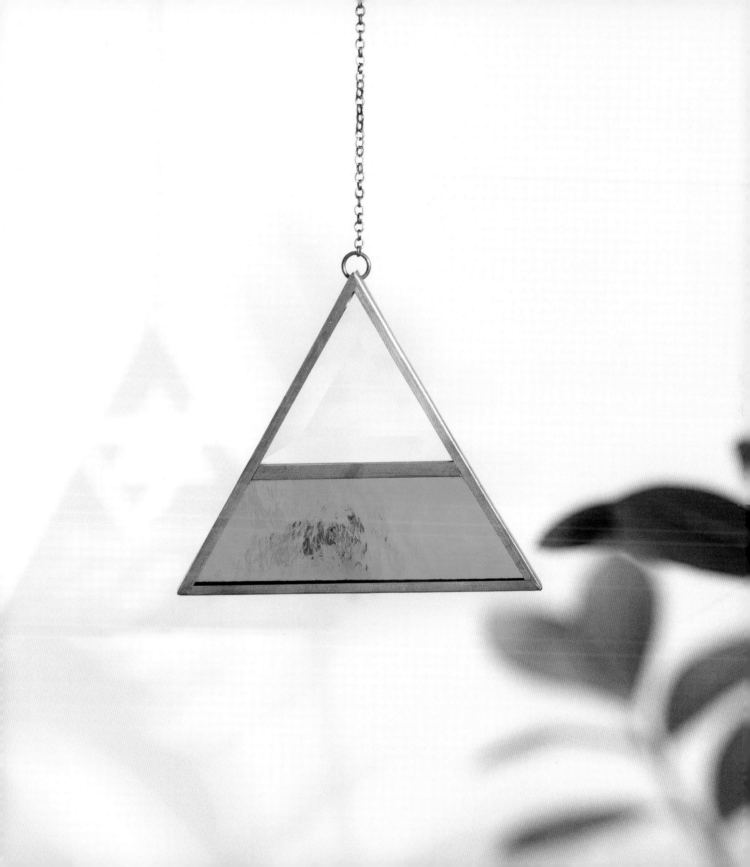

1. Start by tracing the template and cutting the green glass (see The Basics). The other (top) piece of glass is a pre-cut bevelled triangle so it's ready to use. To join the two pieces of glass together, size the H-profile shorter than the glass (2.5mm or 3⁄32in at both ends) as this will allow the brass U-channel that will be wrapped around the piece to fit. Use a small metal saw to cut the brass H-profile.

2. Hold the pieces together with some regular sticky tape.

3. Take the U-channel and mark the length of one side of the triangle with a black marker.

4. At this mark, cut out a triangular piece of brass from the U-channel on both sides with tin snips or with the Lil Notcher.

5. Repeat this until you have the whole piece framed in the U-channel.

6. Use a rubber hammer to flatten the angles.

7. Decide which side looks best – this will be the front of the piece. Secure the piece by tack soldering it on the back (see How to Solder) to secure the brass U-channel, and to attach the H-profile to the U-channel.

8. Remove the tape and clean the brass with some steel wool. Attach one of the split rings with some solder at the top and add the chain, using the second split ring to hang the piece. Use the gold marker to cover the solder points.

Clean your piece before applying the gold marker as otherwise you will just wipe it off.

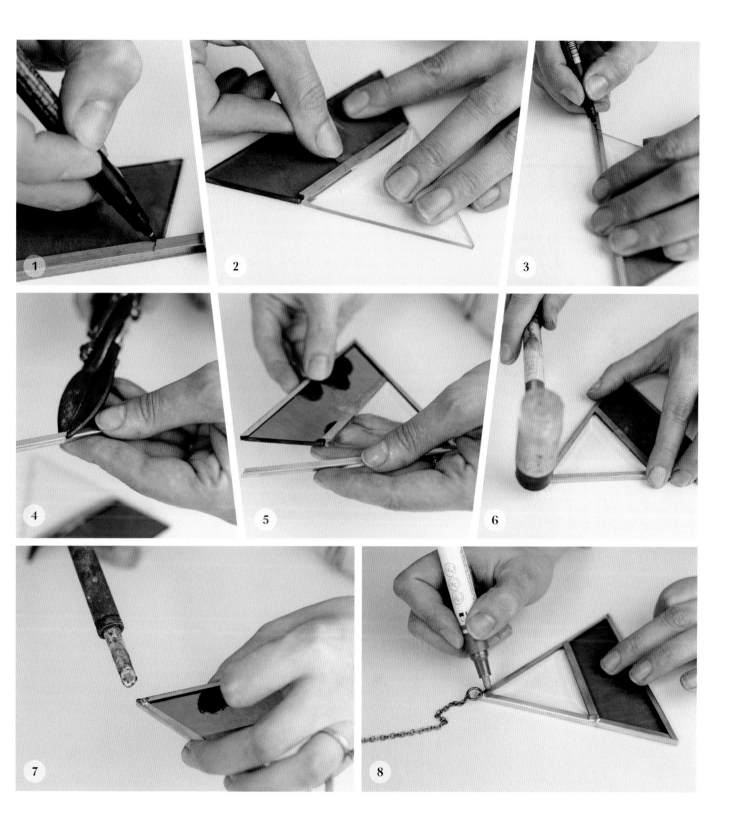

Snowflake with Bevels

A lovely project that requires no glass cutting and the bevelled edges of the glass are an easy way to create extra depth in your work. This is a great project to work on your beading edges skills.

Glass

- 4 x Square Bevel (2.5cm x 2.5cm/1in x 1in)
- 4 x Diamond Bevel (5cm x 10cm/2in x 4in)

Tools & Materials

- 5.2mm (13⁄₆₄in) copper foil tape with black backing
- 5cm (2in) of 1.8mm (13 gauge) copper wire
- Metal hammer
- 50cm (19¾in) of black metal chain
- 2 x 10mm (⅜in) black split rings

Difficulty rating: Easy

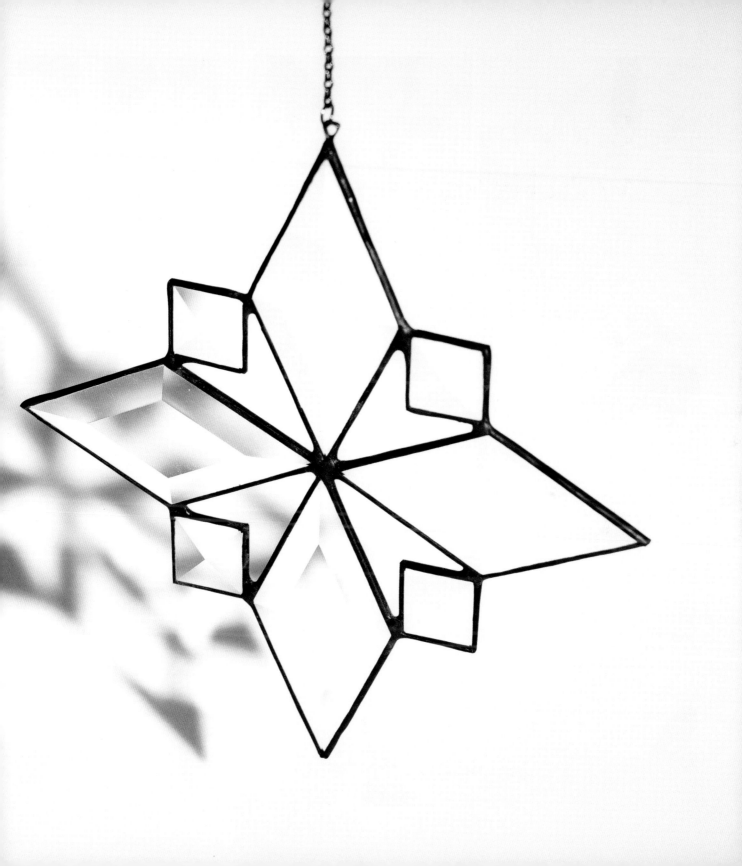

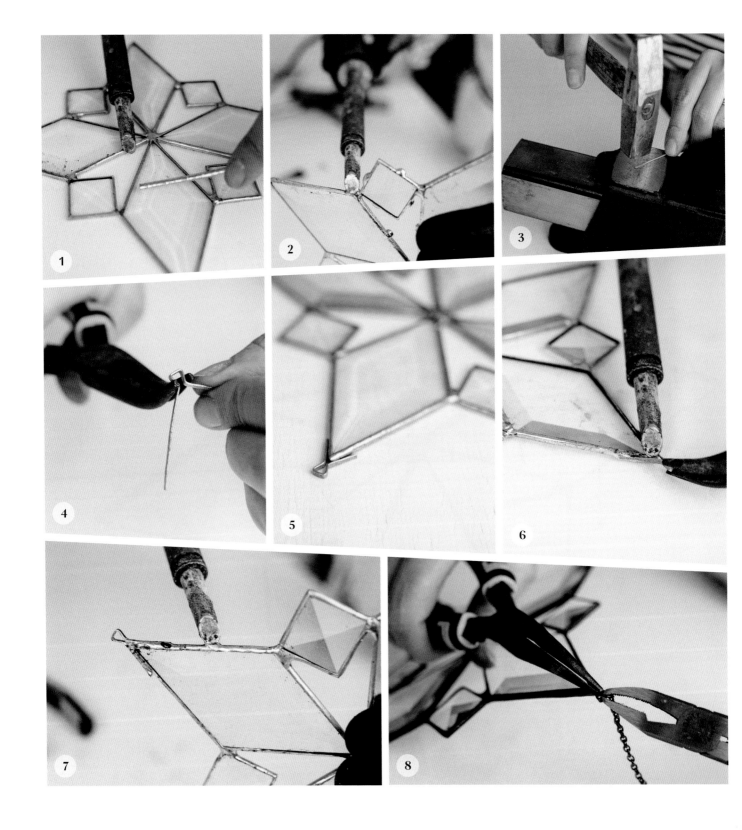

1. Trace and mirror the template along the dotted red line to create the complete template for this project (see How to Transfer Templates). There's no need to grind the bevelled glass pieces, so begin by foiling the pieces and then tack solder them together to form the snowflake (see The Basics). Then tin solder the whole piece.

2. Next, bead solder the snowflake. As the glass pieces are only attached at the corners, it's very important to apply enough solder when beading to the outside of these edges.

3. To create a peg, flatten the copper wire with a metal hammer on a hard surface, such as a vice, until it's about 2.5mm (3⁄32in) wide. In this instance, don't tin the wire before this as that will make the copper wire rigid and more difficult to flatten. We're making this different type of peg as a regular peg would tear off the copper foil over time.

4. Bend the wire with bent nose pliers as shown in the step photograph.

5. Place the peg above one of the large snowflakes and trim the copper wire with cutting pliers for a neater look.

6. Attach the peg to the snowflake with some solder and then tin the whole peg.

7. The biggest challenge in this project is to add enough solder to the sides that you don't see where the peg is attached to the snowflake.

8. After checking the piece thoroughly, it's ready to be finished (see How to Finish a Project). As the final step, attach the black metal chain to the peg using one of the split rings, attaching the other split ring to the end of the chain to hang the snowflake.

Bevels are available in a huge range of shapes and sizes. I've given specific measurements to be able to make this project but have fun creating different snowflakes by assembling them in different ways or using other bevelled pieces.

Geometric Mirror

Mirror, mirror on the wall, you're the fairest of them all! Working with mirror requires extra attention but the results are worth it. Combining different shapes and sizes is a great way to add interest to an empty wall.

Glass

- Bullseye Deep Cobalt Blue Opal 0147-050
- Bullseye Neo-Lavender Opal 0142-050
- Bullseye Teal Green Opal 0144-050
- Mirror glass (2mm/³⁄₃₂in to match Bullseye Glass)

Tools & Materials

- 4.8mm (³⁄₁₆in) copper foil tape with black backing
- 50cm (19¾in) of 0.8mm (20 gauge) brass wire
- 63cm (24¾in) of 2mm (³⁄₃₂in) round U-lead came
- Black marker pen
- Mirror edge sealer or clear nail polish
- Circle cutter
- Vice or lead came stretcher

Difficulty rating: Medium

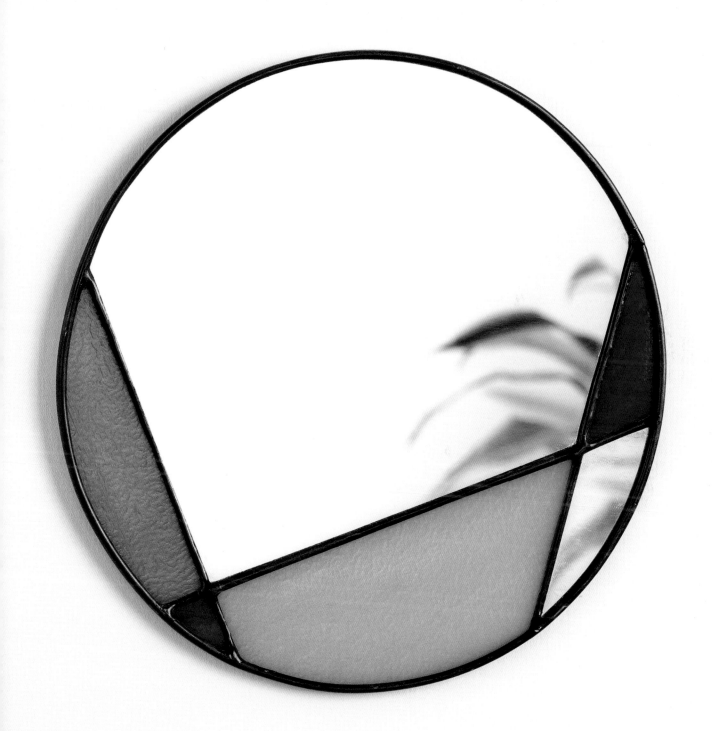

1. Start by tracing the template (see How to Transfer Templates) and cut it into six pieces. Next, cut a 20cm (8in) circle of mirror glass (see How to Cut Glass). Trace the central mirror piece (numbered 2 on the template) with a black permanent marker onto the mirror and cut away the excess pieces. Cut and grind the five other pieces until they make a perfect circle again (see How to Grind Glass).

2. To avoid mirror rot, treat all edges of the mirror pieces with mirror edge sealer or clear nail polish. When the sealer has dried, you can remove the excess with a razor blade. However, leave the excess on the back of the mirror, as you will damage the mirror layer if you try to remove it.

3. After foiling all six pieces (see How to Foil Glass), assemble and tin solder them together (see How to Solder). Only use a thin layer of solder on the edges of the mirror to leave space for the lead came.

4. Turn the mirror over and tin solder the back. Then install the suspension wire using twisted brass wire (see Materials: Twisted Wire). Bend both ends by about 2.5cm (1in) so you're able to connect them to a solder line (see the dashed line on the template for where to place the wire).

Lead came is the best material to use with round or curved objects as it is bendable.

5. Aim to keep the wire 3mm (⅛in) away from the edge of the circle to leave room for the lead came.

6. Stretch the piece of lead came (see Materials: Lead) and solder one end to the mirror where a solder line meets the edge of the circle.

7. Bend the lead around the mirror until you reach the starting point and cut the excess lead with cutting pliers.

8. Solder the beginning and end together on all three sides (edge, front and back). Finish all of the solder lines neatly and connect the lead came to the mirror where the solder lines meet the lead. After checking the piece thoroughly, it's ready to be finished (see How to Finish a Project).

Always be careful when working with mirror as it scratches easily. As always, make sure your work surface is clean. Cut the mirror glass on the glass side. Where possible, avoid grinding the mirror glass. If you do have to grind, use a fine grinding bit and a lot of water. Grind with the glass side down as chips of the silver mirror layer tend to come off when you grind it.

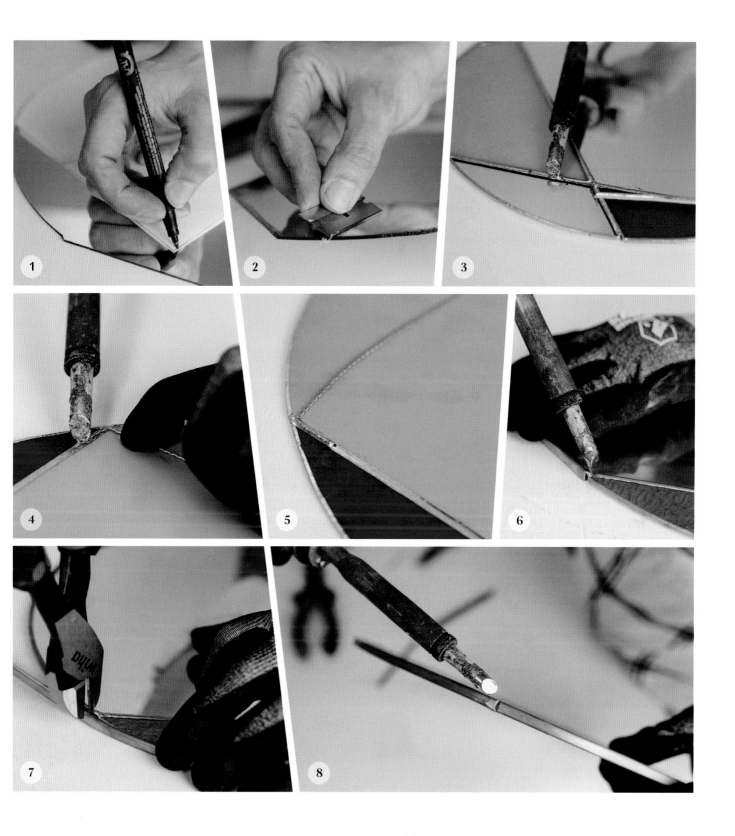

Templates

All templates are shown at actual size. Where a number of colours are used in a project, the pieces are identified by the glass code. Multiple pieces of the same shape are also indicated. You can download printable versions of these templates from www.davidandcharles.com.

Poppy Suncatcher

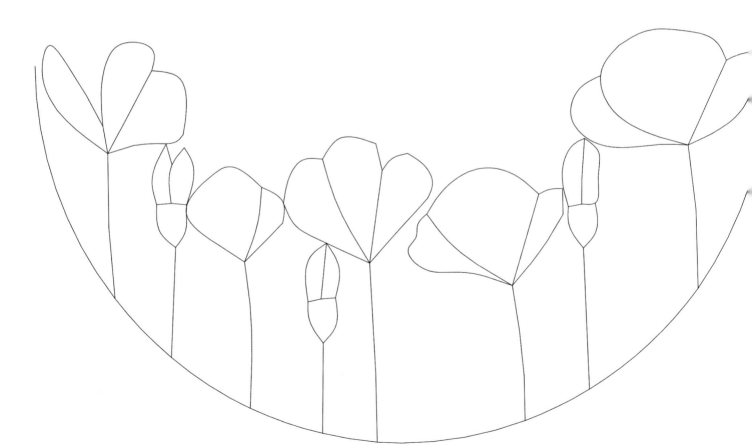

Diamond Suncatcher

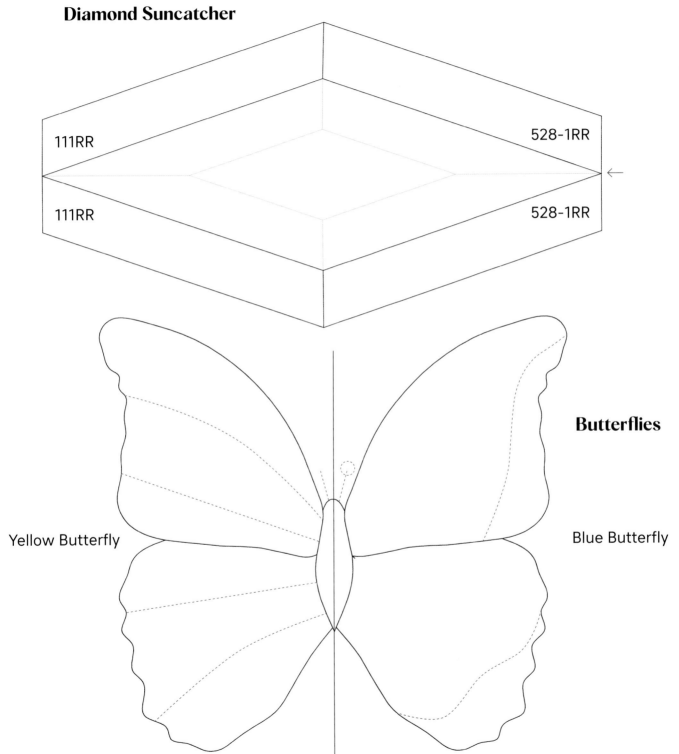

111RR

528-1RR

111RR

528-1RR

Butterflies

Yellow Butterfly

Blue Butterfly

Angular Terrarium

2
(x1)

3
(x6)

4
(x1)

5
(x1)

6
(x5)

1
(x6)

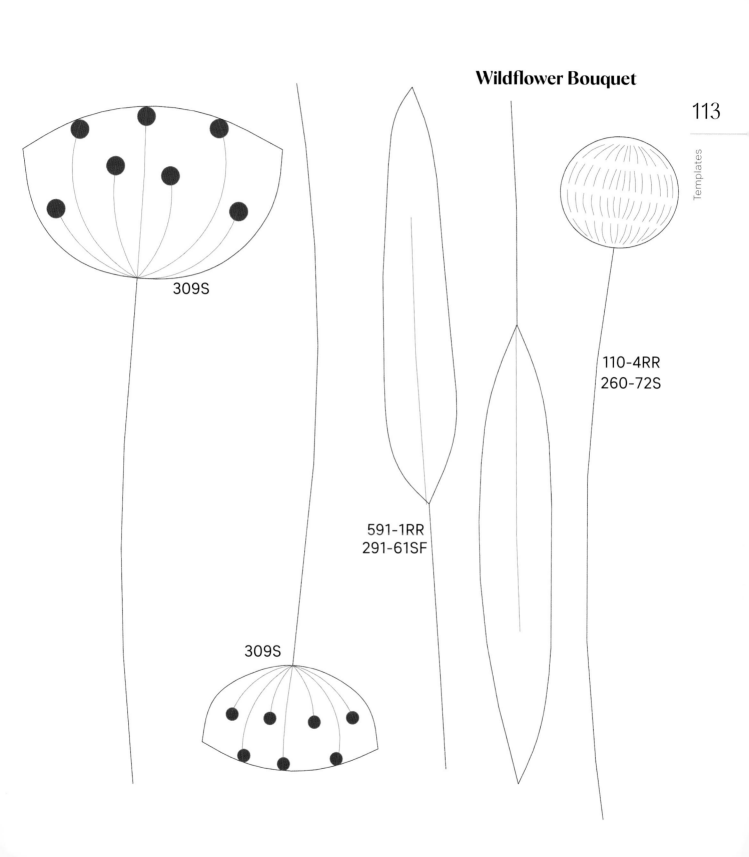

309S

309S

591-1RR
291-61SF

110-4RR
260-72S

**Wildflower
Bouquet**

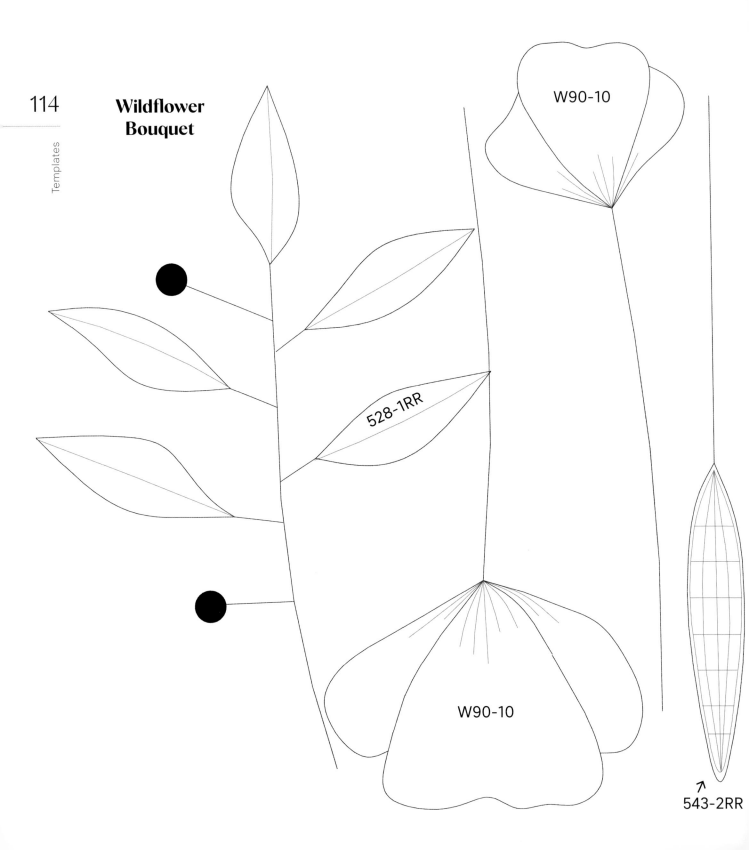

W90-10

528-1RR

W90-10

↗
543-2RR

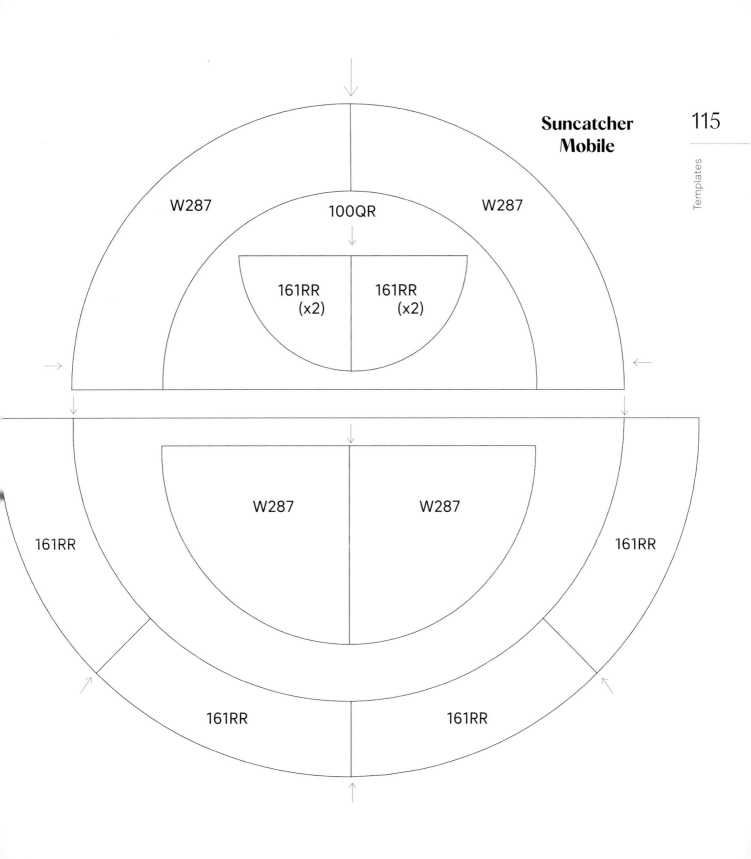

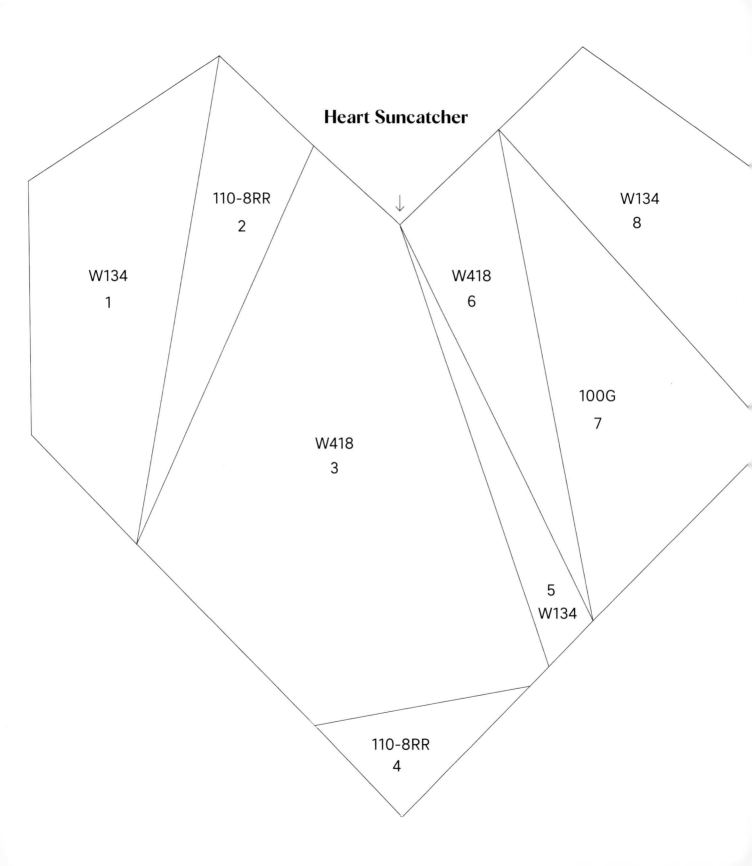

Heart Suncatcher

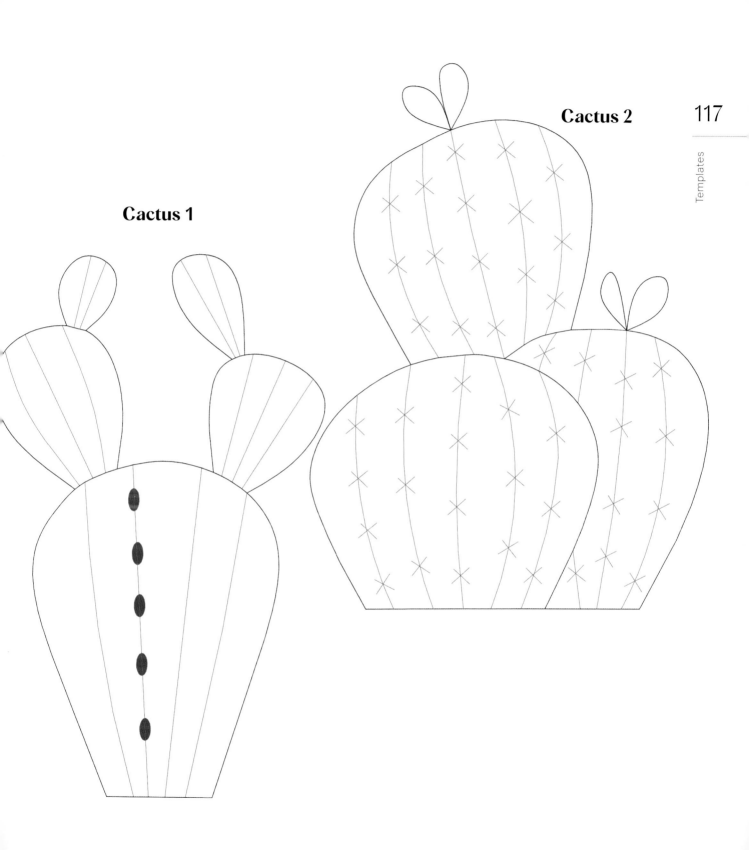

Cactus 1

Cactus 2

1
(x5)

2
(x5)

**Art Deco
Planter**

3
(x5)

4
(x1)

Square Panel

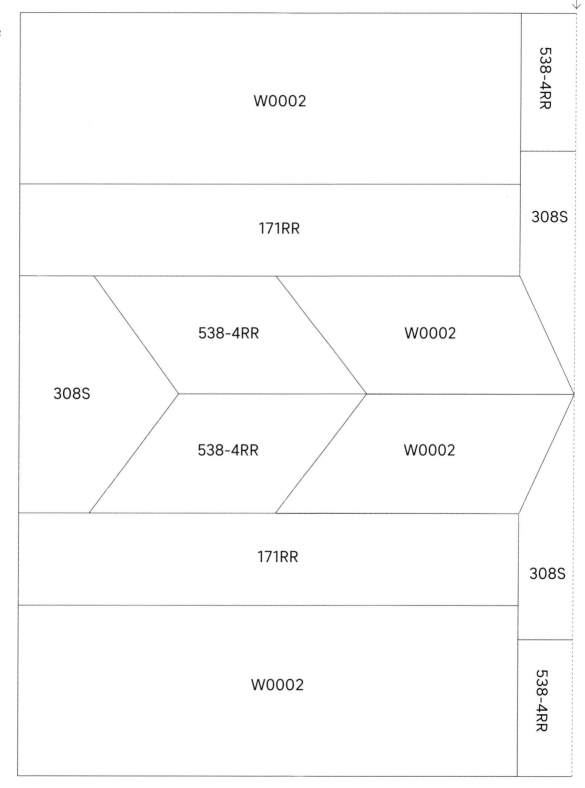

W0002

538-4RR

171RR

308S

538-4RR

W0002

308S

538-4RR

W0002

171RR

308S

W0002

538-4RR

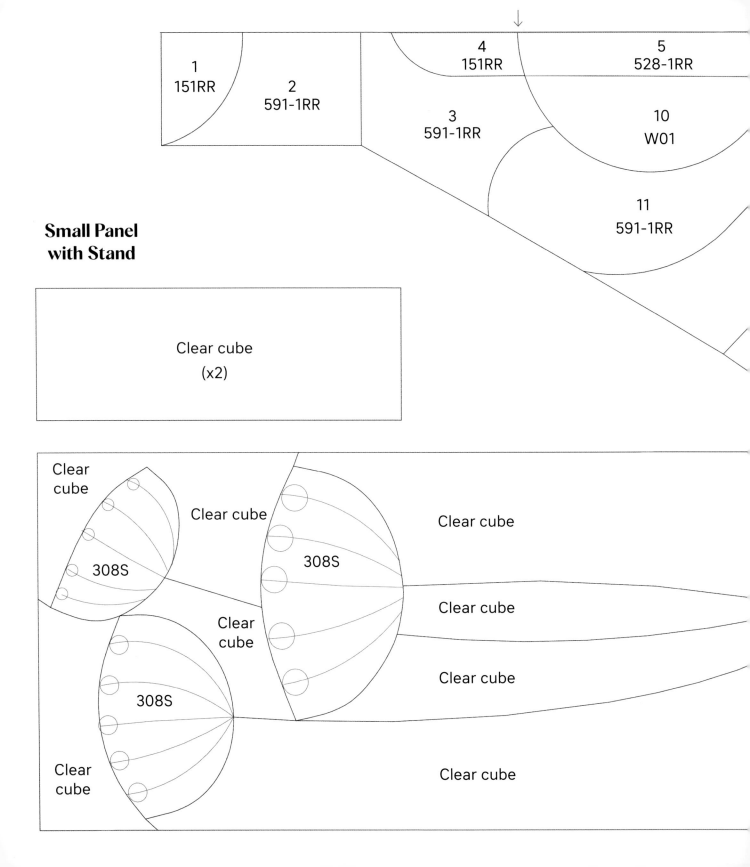

1
151RR

2
591-1RR

4
151RR

5
528-1RR

3
591-1RR

10
W01

11
591-1RR

**Small Panel
with Stand**

Clear cube

(x2)

Clear
cube

Clear cube

Clear cube

308S

308S

Clear cube

Clear
cube

Clear cube

308S

Clear cube

Clear
cube

Clear cube

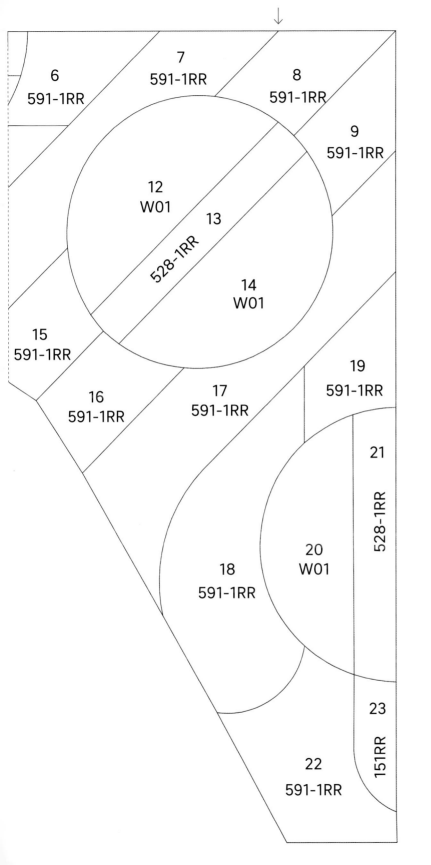

6
591-1RR

7
591-1RR

8
591-1RR

9
591-1RR

12
W01

13
528-1RR

14
W01

15
591-1RR

16
591-1RR

17
591-1RR

19
591-1RR

21
528-1RR

20
W01

18
591-1RR

23
151RR

22
591-1RR

Corner Panel

24
591-1RR

25
151RR

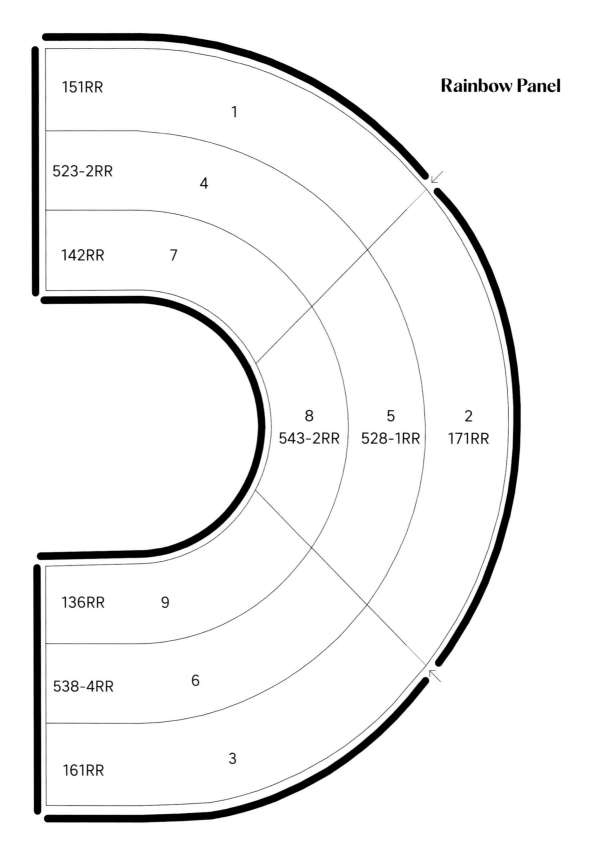

Rainbow Panel

151RR 1

523-2RR 4

142RR 7

8
543-2RR

5
528-1RR

2
171RR

136RR 9

538-4RR 6

161RR 3

Round Panel

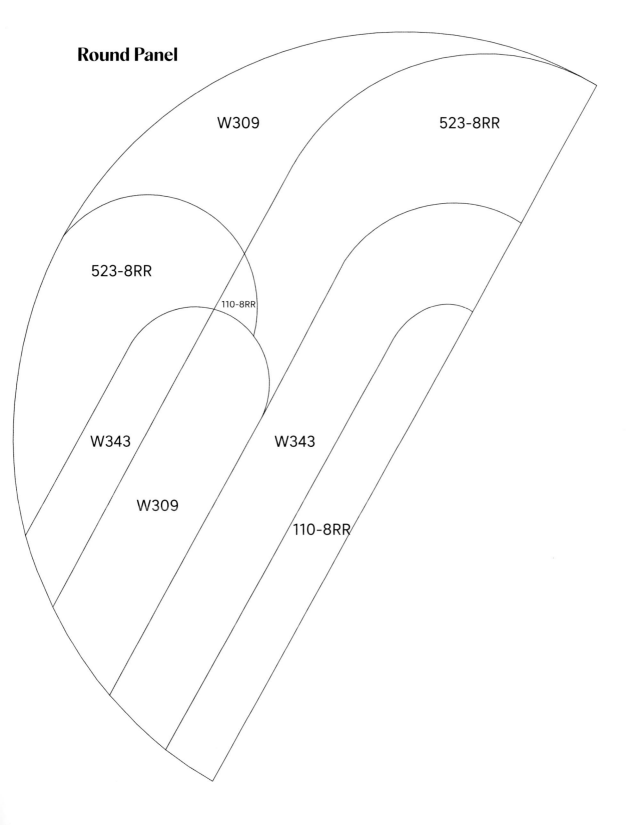

W309

523-8RR

523-8RR

110-8RR

W343

W343

W309

110-8RR

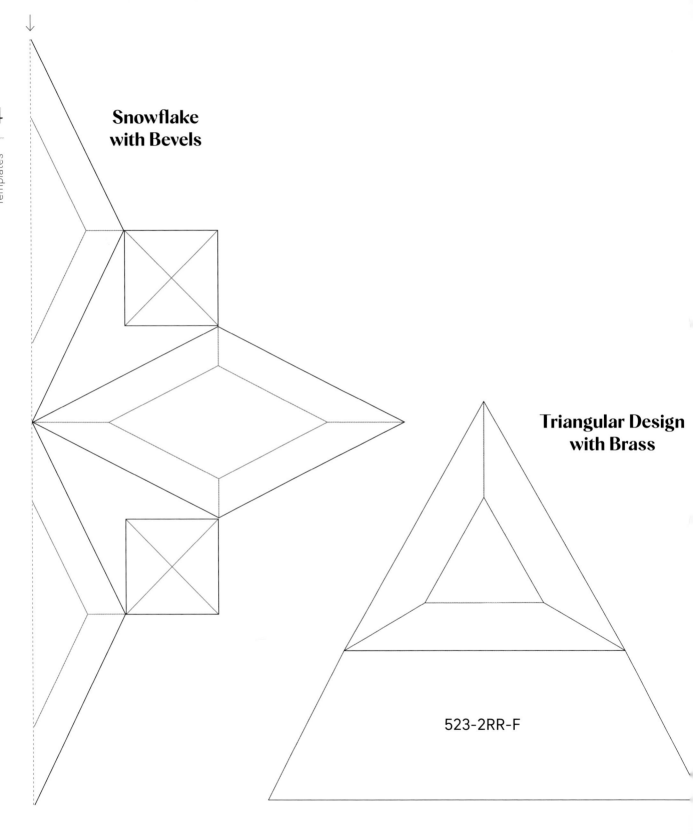

**Snowflake
with Bevels**

**Triangular Design
with Brass**

523-2RR-F

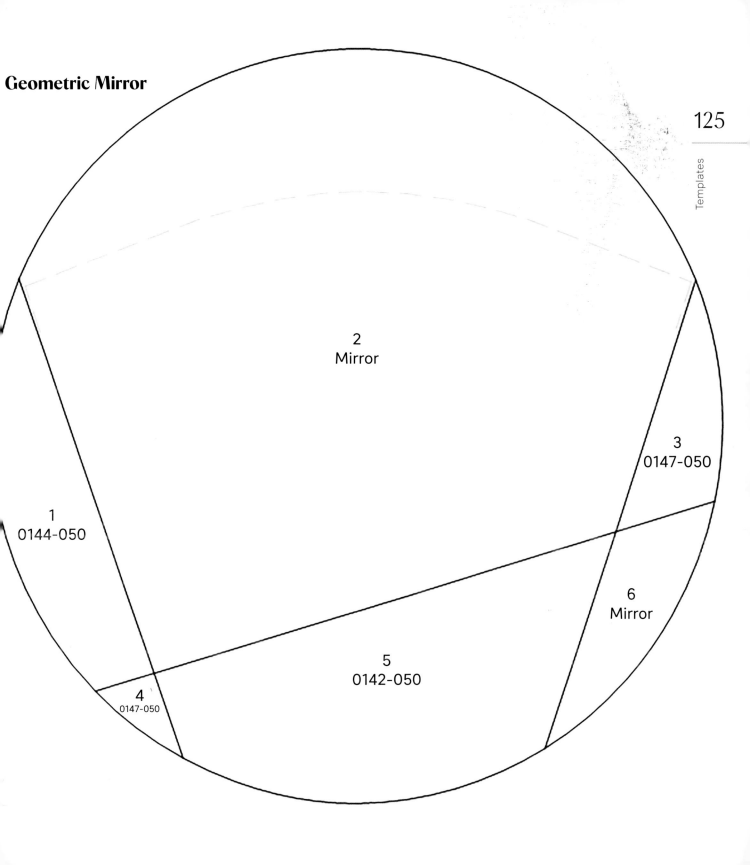

Geometric Mirror

2
Mirror

3
0147-050

1
0144-050

6
Mirror

5
0142-050

4
0147-050

About the Author

I'm a glazier in my heart and soul, and a passionate craftswoman too. It all started 20 years ago with my Masters degree in Leaded Glass Conservation / Restoration.

After finishing my education, I worked in several stained-glass workshops where I learned a lot. I really like restoration but creating new designs is where my heart lies. Also, I wanted to show the world another side of glass, away from the typical church windows. So after turning our garden house into a workshop I started creating and experimenting.

My aim was to create designs that use up as much leftover glass from bigger projects, or recycled glass from old windows, as possible. So even though I initially was working with lead, I quickly turned to using copper foil since it creates much finer lines and that's a plus when making the small designs that I make.

Slowly but surely I started to create and sell my designs under the name Glas & Glas, but winning the people's Pick Etsy Design Award in 2021 with my stained-glass wildflower bouquet was the cherry on the cake!

You can find me on Instagram @glas_en_glas – I'd love to see your creations.

Suppliers

There are many stained-glass suppliers but here's the list of my own suppliers who have webshops, so if you can't find what you need nearby you can always order directly. You can find galvanized steel wires in garden stores or look them up online.

• Armstrong Glass Company: www.armstrongglass.com

• Fenix Glas: www.fenixglas.nl

• Korse Glas: www.korseglas.nl

• Modelbouw Baillien: www.modelbouw-baillien.be

• Zierikzee Glas: www.zierikzee.nl

Thanks

To Ivan, for your patience, To Mindy and Dad for helping me out in the workshop and a big thank you to all my close friends and family for listening!

Last but not least, a big thank you to everybody at David and Charles who helped me make this book a reality!

Index

A DAVID AND CHARLES BOOK
© David and Charles, Ltd 2023

David and Charles is an imprint of David and Charles, Ltd
Suite A, Tourism House, Pynes Hill, Exeter, EX2 5WS

Text and Designs © Noor Springael 2023
Layout and Photography © David and Charles, Ltd 2023

First published in the UK and USA in 2023

Noor Springael has asserted her right to be identified as
author of this work in accordance with the Copyright,
Designs and Patents Act, 1988.

All rights reserved. No part of this publication may be
reproduced in any form or by any means, electronic or
mechanical, by photocopying, recording or otherwise,
without prior permission in writing from the publisher.

Readers are permitted to reproduce any of the designs
in this book for their personal use and without the prior
permission of the publisher. However, the designs in
this book are copyright and must not be reproduced
for resale.

The author and publisher have made every effort to
ensure that all the instructions in the book are accurate
and safe, and therefore cannot accept liability for any
resulting injury, damage or loss to persons or property,
however it may arise.

Names of manufacturers and product ranges are
provided for the information of readers, with no intention
to infringe copyright or trademarks.

A catalogue record for this book is available from the
British Library.

ISBN-13: 9781446309445 paperback
ISBN-13: 9781446381984 EPUB
ISBN-13: 9781446310472 PDF

This book has been printed on paper from
approved suppliers and made from pulp from
sustainable sources.

Printed in Turkey by Omur for:
David and Charles, Ltd
Suite A, Tourism House, Pynes Hill,
Exeter, EX2 5WS

10 9 8 7 6 5 4 3 2 1

Publishing Director: Ame Verso
Senior Commissioning Editor: Sarah Callard
Managing Editor: Jeni Chown
Editor: Jessica Cropper
Project Editor: Clare Ashton
Head of Design: Anna Wade
Designers: Lucy Ridley and Jo Langdon
Pre-press Designer: Ali Stark
Art Direction: Lucy Ridley
Photography: Jason Jenkins
Production Manager: Beverley Richardson

David and Charles publishes high-quality books
on a wide range of subjects. For more information
visit www.davidandcharles.com.

Share your makes with us on social media using
#dandcbooks and follow us on Facebook and
Instagram by searching for @dandcbooks.

Layout of the digital edition of this book may
vary depending on reader hardware and
display settings.